LETTERING WITH LOVE

The simple art of handwriting with watercolour embellishment

by
Sue Hiepler and Yasmin Reddig

hello ♡

We are delighted that you have picked up this book, because it is full of our love and passion: hand lettering and watercolour art. Our lives would be nowhere near as enjoyable without our brushes, pencils and paints.

What do we like doing most of all? Designing pretty things on paper that sweeten daily life. Illustrating and lettering are part of who we are, and we are so grateful that we are able to live our dream every day. And it is exactly our passion which we would like to share with you!

In our creative studio, in the beautiful old part of Bonn in Germany, we have spent many days and nights – accompanied by our two furry friends, Ella and Gremlin – putting our all into writing the book that you are now holding in your hands. Everything to do with lettering was created by Yasmin; for the illustrations, it was down to Sue.

We hope the following pages inspire you, and we will be delighted to receive photos of your own works of art. Just post a photo of your stunning creations on Instagram with the hashtag #mayandberrybuch.

And now: get ready to roll those sleeves up and get out your paints!

Sue & Yasmin

CONTENTS

CHAPTER 2 – Let's get started

CHAPTER 3 – Creative treasure trove

mayandberry.com
instagram.com/mayandberry
pinterest.de/mayandberry
hello@mayandberry.com

Chapter 1
GOOD TO KNOW

Before reaching for pens, paper and paints, sit down in a quiet spot
and read through the basics of hand lettering and watercolouring.
This chapter tells you what you need to know about lettering and
how to combine it with lovely, colourful illustrations.

WHAT IS HAND LETTERING?

There has been a marked increase in interest for lovely hand lettering over recent years. And quite rightly so. It's such a great thing to do, and with a little patience anyone can learn how to do it. We can share a message in lots of different ways by using special lettering. After all, a love letter written on a computer isn't exactly romantic, is it? We love the process of hand lettering because it makes us feel like we can really switch off. All we need is good light, some paper and our pens.

But why is it called 'hand lettering' and not just 'hand writing'? Basically, it's all about writing letters neatly, but not in the sense of classic calligraphy or cursive handwriting, as was taught in schools years ago. Lettering is about letting your creativity run wild, and about drawing the letters rather than simply writing them out.

Hand lettering vs. typography

Typography refers to the methodical designing of fonts. Some of the best-known fonts are Helvetica, Arial, Times New Roman and Courier. Most were designed to add character to long sections of text. The word 'serif', for instance, is derived from the art of typography. These are tiny embellishments on the ends of letters that make them look a little more classical. Sans serif fonts, by contrast, are considered more 'modern'.

Tiny embellishments added to the ends of letters makes them appear more classical.

HELLO

Hand lettering vs. calligraphy

Calligraphy is the most classical art of penmanship. In the Western world it is recognized in the form of writing, using a quill or fountain pen. There are, however, many different types of calligraphy. In Japan, for instance, brush and ink are used for calligraphy. Anyone who has ever held a fountain pen will know that using a nib and ink takes practice and patience. The soft tips of brushes make the ink flow irregularly: the upward strokes are thin, whereas the downward ones are much wider due to the pressure on the nib. Yet this is exactly what we want to reproduce in lettering, in order to create what is known as the 'faux calligraphy' style (or 'false calligraphy'). But more about that a little later on.

hello

WHY DOES IT GO SO WELL WITH WATERCOLOUR?

Hand lettering looks lovely on almost any surface. Paper, fabric, wood, slate or stone – it simply makes anything and everything look beautiful. Lettering can easily stand alone as a little gem, but it doesn't have to. Illustrations perfectly complement lovely lettering and bring it to life, and they don't have to be particularly complex. With the right technique and a few tips and tricks, you'll soon be able to create the loveliest works of art with your hand lettering.

This book is as much about colour as it is about letters, and there is something particularly magical about watercolour paints. This is due, in part, to the fact that you don't always know what the paints are going to do. You can watch them blend into one another, creating new and random patterns.

Watercolours are extremely versatile, and they make a fabulous background for lettering. The paint is usually diluted with lots of water to create a gentle colour wash on special watercolour paper. Once the paper is dry, the effect and final texture is wonderful for writing on.

Illustrations with watercolours will often increase the expressiveness of your lettering. Not only do they embellish the written message, but they also enhance it and boost the effect of the overall design.

And that's not all! Watercolours are also ideal for the lettering itself. This technique is called 'brush lettering', and is wonderful for creating highly imaginative colour plays and sequences.

WHAT YOU NEED FOR HAND LETTERING

Hand lettering is an art that doesn't need a lot of materials. In other words, you can use basic pencils, printer paper and ballpoint pens for the lettering and create simple, successful designs, just as you would with high-quality papers, brush pens and fineliners in the most diverse colours and versions. Anyone who falls in love with lettering will soon also fall in love with the wide range of wonderful materials available from art supply stores. But let's start with the essentials.

As you work through our book, you'll frequently use the following materials:

Paper: You can never have too many notepads or other kinds of paper for lettering. Basic printer paper of 80gsm (22lbs) is fine for quick designs, and is good for working with brush pens as it is nice and smooth, and feels particularly soft. Tracing paper is very good for working on designs without you having to keep starting again. If you want to give hand-lettered works of art away as a gift then slightly thicker paper, approximately 250 to 300gsm (80 to 112lbs), is a good choice. Personally, we like working with printer card. It is available with both a rough and a smooth finish, and in lots of different colours. Another favourite is kraft paper of 300gsm (112lbs). This brown paper shows lettering – especially in white – at its very best, and is particularly attractive. For more information on surfaces for watercolour letters, please see page 19.

Pencils: A good HB pencil is fine for hand lettering. Just make sure that the tip isn't too sharp, or it will scratch the paper and could leave marks when rubbing out. The perfect pencil should fit comfortably in your hand, not smudge and be easy to rub out. We like to use Faber-Castell pencils.

Eraser: Your scribbles should not leave any marks or traces. A good eraser is one of your most important materials. Poor quality erasers may smear, and in the worst case could also destroy your paper.

Ruler: You will need a ruler, and possibly a set square, to ensure that your lettering work is precise and centred on the paper. Especially when you are just getting started, preparing your work with a ruler will avoid problems later on. It's a shame if you start your work and then realize that it wasn't properly aligned.

Fineliners: These are much better for hand lettering than ballpoint pens because the tips are much finer, and create a more even flow. Fineliners are part of everyday life now, and there is a tremendous range of colours on offer. We usually use ones that are 0.4 or 0.5mm thick; however, sizes from 0.05 to 0.8mm also appeal to lovers of hand lettering. Thin fineliners are ideal for details and very cursive scripts. Look for light-resistant and waterproof fineliner pens, which are perfect for working with watercolours.

Fibre/Felt-tip pens and markers: A fibre/felt-tip pen can take over when a fineliner is not enough. They have solid, fixed tips and are available in a range of sizes and colours. As with fineliners, make sure to use waterproof fibre/felt-tip pens when combining lettering and watercolours.

If you can't get enough of hand lettering, sooner or later you'll probably want to try these materials:

Brush pens: If your heart beats for hand lettering, you won't be able to avoid them. Ultimately, a brush pen is only a fibre/felt-tip pen with a movable tip that acts like a brush, because it bends under pressure. It is important to look after your brush pens as their tips wear out quickly if they are not used with care. In the beginning, brush pens will demand a lot of patience and commitment from you, but with a little practice you'll soon be able to create fabulous works of art with them. Today, there is a wonderful variety of brush pens. They are available in countless colours, sizes and hardness grades, and with rubber as well as fibre tips. There's plenty of choice for every taste.

Paint brush: Of course, brush lettering will also work with paint brushes and paints. The technique is a little more difficult than lettering with a brush pen, because paint brushes are usually much more flexible and more difficult to control. Quality really is the key here. Whether you opt for a brush with natural or synthetic bristles, it should not be worn, and so you also need to look after it well to ensure it retains its shape for a long time. The brushes that we use in this book are ideal both for the lettering and for the illustrations. Our favourites are Da Vinci brushes from the Cosmotop-Spin series.

Watercolours or ink: We have used only watercolours for this book – we just love them. However, ordinary ink is also ideal for the lettering, or writing with a regular fountain pen.

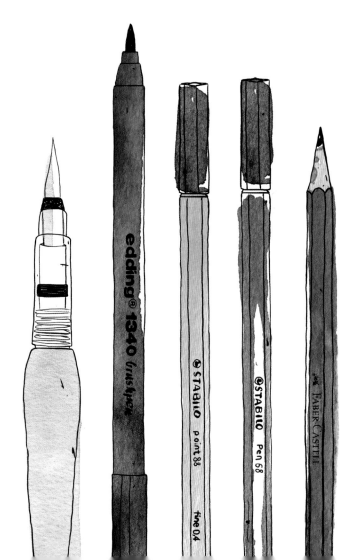

HAND LETTERING BASICS – ANATOMY OF LETTERS

Whether it's calligraphy, typography or hand lettering, they all begin with the letters. We are all familiar with upper and lower case letters; that they can be bold, thin or italic; and that they can be joined together ('cursive') or be printed as single block letters. There are countless shapes and styles, and every one makes a different statement.

The art of writing shapes us from our earliest years, even though we might not be aware of it at the time. We see written words everywhere: on signs and signposts, advertising posters, books, computers – they are all scripts with a specific message.

If you want to practise lettering, you will have to first look at and understand the fundamental construction of the letters.

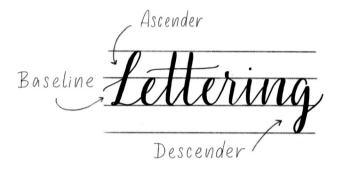

The great thing about hand lettering is that you have almost complete freedom in designing the words. It's different from traditional calligraphy, which can be more rigid in form, in that you don't have to keep to a letter grid. The letters can 'float' up and down; it is important only that you follow a horizontal so that the lettering is balanced at the end. This can be a mental rather than a physical line, although it is helpful to lightly draw it first in pencil.

ATTENTION

If you compare the two types of lettering above, you will see that the message transmitted by the word in capitals is quite different from that of the more ornate handwritten version.

FINELINER AND FIBRE/ FELT-TIP PEN TECHNIQUE

This hand-lettering method is our absolute favourite, because it is easy and it allows you to imitate the style of calligraphy – also known as faux calligraphy. Done properly, you will imitate the ink flow created with a calligraphy pen and create the loveliest looking words. We usually use a black fineliner and/or a fibre/felt-tip pen when we use this technique, and we recommend a pen with a thickness of 0.05 to 0.8mm, depending on how large you want the words to be. Mostly, we plump for a pen with a 0.3mm thickness.

For this approach, start by tracing the 'skeleton' of the word in pencil. Don't be discouraged if your first attempt isn't as good as you want it to be.

Then, go over the pencil lines in fineliner or fibre/felt-tip pen. Try to make the lines as clean and as neat as possible. You can, of course, lift the pen whenever you need to, but it's a good idea to wait until you start a new letter.

In the next step you will double some of the lines. There is one important rule to remember here: you only double the downward lines – the 'downstrokes', or 'descents'. The vertical arches in the word are extremely important here. Use a pencil to draw vertical lines in the middle of each one in the letter; these marks indicate where to start the doubled line, and where it should end.

Finally, fill in the white spaces between these doubled lines. The quickest way is with a fibre/felt-tip pen, but take care to stay inside the lines.

That's how easy it is to convert a handwritten word into hand lettering. The advantage of this technique is that you can decide and control how thick to draw the downward strokes in your letters, and create a smaller or greater contrast between your thick and thin lines.

BRUSH LETTERING WITH A BRUSH PEN

If you're developing an interest in hand lettering, sooner or later you'll have to try brush pens (see also page 11). They are every hand letterer's best-known tool, often combined with a fibre/felt-tip pen and brush. Today, they are available from almost every specialist shop. A few skilful movements of the hand, and you can create a perfect hand-lettered word or phrase. The flexible tip of the brush pen gives as you write, which automatically creates the contrast between the thin upward strokes ('upstrokes' or 'ascents') and the thicker downward ones ('downstrokes' or 'descents').

There is one important thing to remember with this technique: practice. Writing with a brush pen requires plenty of patience, and will take time to master. Head and hand need to get used to adjusting the pressure on the pen. In the early days, it is particularly difficult to control the thin lines that go upwards. Don't be discouraged if they look shaky or quite thick at first.

Practise drawing thin upward lines. For the thick lines, you only have to angle your wrist slightly so that the tip of the brush pen is flatter on the paper.

When writing with a brush pen, watch out when you start a new stroke. You can, of course, lift the pen, but you have to know when and where is best. Ideally, lift off at the end of an upward stroke. This lower case 'h', for instance, is made up of two independent strokes.

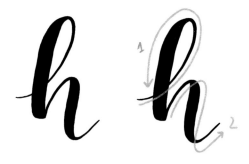

On pages 104 to 105 we have created some simple exercises for you to get used to your brush pens. Once you've built your confidence, try the alphabet exercises on pages 106 to 109 to familiarize yourself with writing out the letters with your pen. You'll be amazed by how quickly you improve.

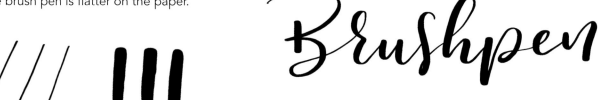

BRUSH LETTERING WITH A PAINT BRUSH

A paint brush and watercolour paints, or ink, are also ideal for lettering. We like using the liquid watercolours by Ecoline or the box of watercolours by Schmincke for our illustrations and paint-brush lettering. You can find out more about these products and the various options for choosing colours on pages 24 and 110. For now, all you need to get started is a tapered brush (size 6 is our favourite), watercolour paper, paint, water and a mixing palette.

In your palette, mix a small amount of paint with plenty of water. Take the brush in your hand and write a word, letter by letter, with your mixed paint. Then, touch over the bottom edges of the wet letters again, either in the same colour or a different one. You'll see how the colours flow together and create a pretty gradient of colour.

Lettering with a brush is, logically, called brush lettering. The technique is basically the same as when writing with a brush pen, the only difference being that brush tips are far more flexible, and a little more difficult to control. The lovely thing, though, is that it is the slightly imperfect character of brush lettering that makes the writing look so charming. The watercolours contribute to this special look because the fusion of paint and water create delightful gradients.

The exercises on pages 104 to 109 are also suitable for this technique. It's best to use special watercolour paper, as it can withstand lots of water on the surface. There is information on the various kinds on pages 19 and 110.

15

WHAT IS WATERCOLOURING?

Think of watercolours, and your mind will probably go straight back to your school days. There you were, sitting in front of a paint box, wearing one of your dad's old shirts to protect your clothes, and trying your hand at a family portrait with a thick bristle brush – the main thing was it had to be bright.

But there is so much more to the art of watercolour. Unlike painting with acrylics, for instance, it is not about perfection. Water-soluble paints do exactly as they please – a little more or a little less water, and the paint will move freely over the paper. And, in our opinion, that is the very thing that explains our passion for watercolour paint. We're not interested in copying something exactly from a photograph, or about capturing a moment with a few splashes of paint. For us, it's about capturing the essential qualities of a motif, and seeing how much we can leave out without it losing its shape. It inspires us to see how few brush strokes are required to reproduce a flower.

These days, when perfection is a part of everyday life, what could be more enjoyable than just picking up a paint brush and painting without thinking hard about creating a miniature work of art, the likes of which will never be repeated?

WHAT YOU NEED FOR WATERCOLOURING

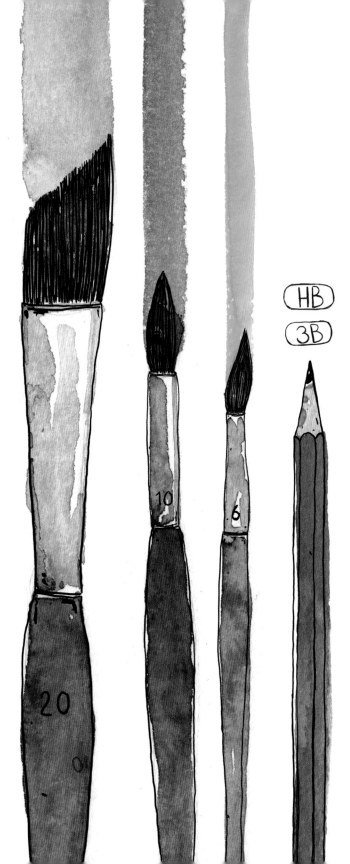

You don't need much for painting with watercolours.
The basics are:

Pencil
Eraser
Round paint brush
Broad or flat paint brushes
Watercolour paints
Watercolour paper

Paint brush: There's no easy answer to the question of choosing the correct brush. There is such a tremendous range of brushes available, and the differences in prices are equally large. It's usually the bristles, or hairs, that determine the price. You can choose between (inexpensive) synthetic or (expensive) sable hair. We would advise buying two high-quality round brushes rather than ten cheap ones, in sizes 6 and 12. You don't need any more at this stage. It is important that the brush head is tapered and pointed. Even a very thick brush can have a very fine tip, depending on the quality. You can use it to draw both very thick and very thin lines. Unlike round brushes, broad or flat brushes are used more for large areas such as backgrounds. One large broad brush is sufficient for your starter set. For all our watercolour brushes, we like using the Cosmotop-Spin range by Da Vinci as they are very soft and do not fray.

Pencil: Sketching is a great help, especially at the beginning when you're building your confidence. Drawing is a breeze too with the right grade – an HB pencil, which is not too soft and not too hard, is perfect. The lines will be fine but still easy to see. They're also easy to rub out.

Note – Take care not to press down too hard on the pencil, as this could cause grooves in the paper that paint may collect in later on.

Find out more about watercolour paints on page 24.

Paper: No two watercolour papers are the same. There are lots of different varieties that can mostly be divided into rough (very textured), cold-pressed (some texture/matt) or hot-pressed (smooth/satin). Every surface has its advantages. Rough paper adds a special texture to the illustration, and the effect of the paint on it is different from that achieved on, for instance, smooth paper. Satin watercolour paper is ideal when working with brush pens, as these can quickly fray on rough paper. At 200 to 300gsm (80 to 112lbs), watercolour paper is thicker than normal drawing paper that weighs from 100 to 150gsm (54 to 68lbs). Watercolour paper comes in a practical pad that is usually glued in; this helps the paper keep its shape, even if you use lots of water when illustrating. Once the paper is dry, you can carefully ease it away with a small knife. We like using paper by Hahnemühle. They have a tremendous selection: basic sketch pads, lovely watercolour paper in various grain sizes and handmade papers – whatever your heart desires.

Tip: Low-priced watercolour paper is fine while you are still getting used to using watercolour paints.

Hahnemühle

PLAYING WITH TRANSPARENCY

In lots of famous paintings, you can see how the artist played with light and shadows. And this doesn't have to be difficult – there are lots of ways to highlight certain parts of an illustration, or push them into the background. One easy way in watercolour is to play with the transparency, or in other words make the various layers of paint more or less transparent than others. This allows you to create a softer appearance for features you don't want to be in focus – usually in the background – or use different layers of paint to create three-dimensionality within these same features.

The branch opposite illustrates this point. Paint a few leaves with lots of water mixed into a little paint, and they will 'fade' into the background. Use a stronger colour for the remaining leaves, by adding more paint to the mix, and the branch will not only look more interesting but will also have more depth and credibility.

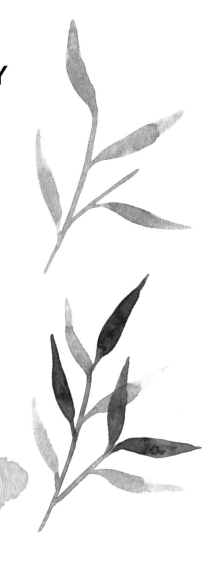

Tip: You can also see this 'faded' effect in nature. For instance, look at a landscape with mountains; you'll see how the colours of the ones at the front are far stronger than those in the background. Many painting techniques are inspired by nature – try to take more notice of your surroundings, and you'll be amazed by the things you see.

LEAVING WHITE SPACES

Every watercolour painting will look more effective if, rather than simply filling in every part with paint, you leave some sections without any paint at all. These white spaces add depth to the illustration, and look like light spots.

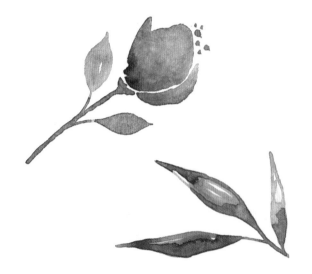

For instance, you can separate the petals of a flower so that it is more identifiable, despite its abstract form. A few white areas here and there will also create highlights in your painting, which will make it look much livelier.

The white spaces are created simply by deliberately leaving certain sections of the paper untouched. Another option is to roughly paint in the leaves and petals, and not to worry about colouring them neatly.

It is important to consider these white spaces when working with watercolours, as it is almost impossible to add white areas later on. The typical method in watercolour of layering the paint darkens the painting step by step, and it is these layers that make it

impossible to place white paint over a darker colour. Things are different, for instance, in acrylic painting, where all you have to do is reach for the tube of white paint to add highlights.

As we don't have this option in watercolour, you need to decide ahead where you want your white sections and then take care to leave those areas blank. In the beginning, it is difficult to know and work out in advance where the white spots will be most effective. All you can do is spend time experimenting with your paints and practise, practise and practise some more – and not get disheartened.

THE COLOUR FLOW – WASHES

What is most fascinating about watercolours is the unpredictable way they flow together. You can almost never tell how the shade is going to develop – will it be more blue or more yellow, or will the two colours blend completely? And the results will differ again, depending on the amount of water you use.

In watercolour painting we really only differentiate between two painting techniques: washes and glazes. A wash is about letting the paints do what they want. Several colours are applied wet to wet paper which makes the paints flow together, creating different gradients. This technique is especially effective for leaves. A leaf is never only one colour; the stalk is usually a little darker than the centre, and will develop yellow or red areas in autumn.

Tip: The key to successful wash painting is the dampness of the paper. If it is too dry, the paints won't run together properly. If it is too wet, the water stays on the paper.

Start by painting a leaf on wet watercolour paper in a very dilute shade of green, made with lots of water and a little paint mixed in.

Then, with a little stronger colour on the brush, dab a tiny amount along the base of the leaf. The paint will slowly run through the leaf all the way up to the tip.

Tip: Give the water time to spread. The paints will continue to develop and run together as they dry.

This technique also works the other way around. Paint the outline of a leaf in with a strong mix of green. Again, the secret is to find the right ratio of paint to water. Rinse out the brush completely and use the wetness of the bristles to draw the paint from the damp edges of the leaf towards the middle. This will also create a graded wash that will make the leaf look more three-dimensional.

LAYER BY LAYER – GLAZES

The second important technique in watercolour painting is glazing. Painted areas are left to dry, and a second, thinned layer of paint is then applied on top so that the underlying layer still shines through. Of course, you can also apply several layers of paint on top of one another – as long as the bottom layer is dry, so they don't all run into one another.

Different colours mix optically on the paper. For example, if blue is painted over red the eye perceives the area where the colours blend as purple. If the same colour is used for each layer, then the colour will deepen in shade with each layer.

This technique can be used in lots of different ways. If, for instance, you want to paint a lush, brightly coloured bouquet of flowers, the glazing is a good way to layer lots of flowers and leaves. Try leaving the leaves in the background a little transparent; this creates depth.

Using several layers of paint will also make a single flower look more three-dimensional. A flower is always a little darker on the inside, because the light tends to fall mainly on the open petals. By applying a couple of layers in the middle, it will give the flower far more realism and body.

Tip: Dimensionality can be achieved with either washes or glazes. In the end, it is up to you to decide which technique you want to use – it's all a matter of taste. Both methods require practice, so focus on one to begin with and then build your skills by tackling the other. In the end, using a combination of both techniques will make your illustration more exciting.

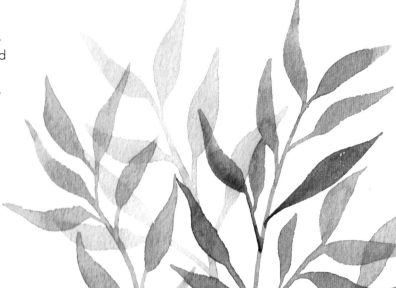

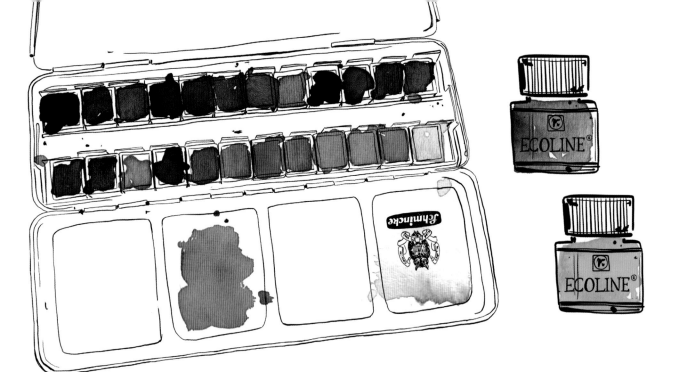

THE RIGHT PAINTS

The projects in this book have all been worked in two different types of paint, one is regular watercolour paint (we use Schmincke Aquarell) and the other is liquid watercolour (we use Ecoline). Which colours you choose is a matter of personal taste, as both types have their advantages.

Liquid watercolours are effectively the same as ink or airbrush paints. They are available in small pots, already mixed with water, and are made from synthetic pigments, which is why they have such a strong luminosity. They are suitable both for watercolour paper and for other bases, such as cardboard or drawing paper. Ecoline watercolours are not waterproof, so even when your works of art are dry you can wet them with water again and continue painting. They are also ideal for hand lettering.

Tip: Liquid watercolours and brush pens are compatible with each other, so you can dip a brush pen in a pot of paint and create colour gradients in your writing.

Regular watercolours are available in tubes and pans. We are terrific fans of our Schminke Aquarell painting sets with pans. They are ready for use, so you can start painting as soon as you open the lid. When you are first getting started, the smaller starter set with twelve colours is perfectly adequate. You can mix lots of other colours from the basic colours in it.

MIXING COLOURS

Mixing colours is an important part of watercolour painting; after all, the choice of colours in the average watercolour set is limited. However, mixing colours is not necessarily easy for a beginner. It is difficult to estimate the correct amount of paint, and it is all too easy to mix a few colours and end up with a dirty grey or dark brown. But don't let this discourage you! Playing with colours is a skill you'll perfect with time.

To begin with, never mix more than two colours and always use the lighter one as the base, as it is particularly difficult with liquid paints to lighten a dark shade. For practice, start with yellow and gradually add a little more blue, and see how the various shades develop. Take time trying out various colour ways. At some point, you will instinctively understand the subtleties in shades and create the right colour combinations.

Tip: Making colours work naturally together is an excellent method to use for floral illustrations. If, for instance, you want to use red for the flower and green for the leaves, then add a tiny bit of green to the red, and vice versa. This makes the two colours look more 'related' to each other.

CREATING COLOUR SCHEMES

Before you start drawing, you can create your own colour scheme. This is used as a sort of aide-memoire, and will help you to try out and select the colour combinations for your illustration. Draw a number of little boxes on your sketching paper. Fill two with your two main colours, and gradually add more and more colours. With the colour fields close together like this, you will have a better understanding of the ones that go together.

You can paint the various grades of your colours in another row of boxes below the main shade. This will show you how light or dark the colour can be. Trying them out in advance will also help to reduce your fear of the white sheet of paper.

Tip: Scrap paper is absolutely essential in our daily work. We use it to try out new brushes and paints. How strong is the colour? What does it look like on the paper? Is there too much water on the brush – or perhaps not enough? How thin will the lines be with this brush? Use this piece of paper as often as possible. It will make you feel much more confident when you use your paints and brushes.

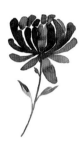

Chapter 2
LET'S GET STARTED

After all this theory, it's time to start being creative!
On the following pages, you'll find instructions and inspiration for
your own lettered and painted works of art. Whether you decide
to give them away or use them to decorate your own four walls
is entirely up to you. The main thing is you enjoy yourself, and
steadily grow confident enough to try a range of hand-lettering
styles, colours and illustrations.

KEEP IT SIMPLE

Not everything has to be complicated. Especially when we are learning something new, we often put ourselves under pressure unnecessarily because we want everything to be perfect from the start. In the first instance, drawing and lettering should be enjoyable. The difficulty of your chosen motif is not so important. This project should help you to remember that even something simple can be really effective. You can easily create a lovely work of art with an uncomplicated watercolour background, made with a straightforward single-colour wash.

This project is created on rough watercolour paper in size A4 (8¼ x 11¾in). As you need lots of water for the graded wash, it is a good idea to use thick paper with a rough surface. Use a size 20 flat paint brush for the background and a fineliner and a fibre/felt-tip pen for the lettering. You will also need a pot of water, a small pot or dish for mixing, and an HB pencil, a ruler and an eraser for the lettering later.

Colour palette

1. Paint your background first. Pick up a strong colour of your choice from your main palette (we have used red here), and then thin it with lots of water in your separate small pot or dish.

2. Wash the brush completely. Generously wet the paper with your brush and paint clear water in the areas where you want to have the background. It is important to find the midway between too wet and too dry. If the paper is too dry the paint will not run, but if it is too wet the water will remain on the paper and the colours won't spread out properly. Ideally, aim for a lightly damp surface.

Tip: If you have used too much water, you can soak some up with the brush. Wash your brush completely and dry it with a tea towel or kitchen paper. When you now put the brush on the paper, it will slowly soak up the water.

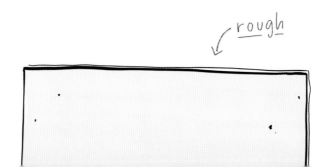

rough

3. Then, use the brush to pick up a little of the thinned paint and dab it along the edges of your wet area. If you wish, use the final piece on page 31 as a guide. Try to dab rather than brush, as brushing causes smears and tends to make the paper rough.

4. You can also dab a little of the concentrated paint in one or two corners of your wet area. Take care not to make the background too dark overall, otherwise it will be difficult to see the lettering later on.

Take your time, and try different shapes and colours. Graded washes are a matter of instinct, and are often created by chance. Their main advantage is that they don't take long to do, and are the perfect base for practising lettering without messing up an illustration. You can also create basic backgrounds with gentle lines or waves. Just make sure that they are very light so you can see the hand lettering to good effect.

Tip: Want more colour on your design? Simply mix a second colour that corresponds well, thin it and dab it onto the wet paper.

While the background is drying, you can start planning the letters. Here, we have combined two different types: one is an elongated capital letter and the other our beloved 'rope script', otherwise known as cursive script. You'll find a template for the whole alphabet in this style on page 102.

Tip: Keep your pencil drawing as light as possible so it is easy to rub out. When lettering in watercolours, it is particularly important to make sure that no marks are left after rubbing out the pencil lines.

5. Using the ruler and HB pencil, draw three horizontal lines on the dried wash. The lines should be positioned in the middle of the paper.

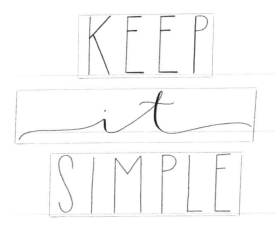

6. Draw elongated rectangles around the lines in the places where you want to put the words. This will make sure that you position the letters correctly.

7. Start with the words 'keep' and 'simple', taking care not to press down too hard with your pencil. To begin with, you just want the bare bones of your letters.

8. Now draw the 'it' between these two words. Make sure that the stylistic ends (or 'swashes') are relatively long at the beginning and end, so that the lettering looks flowing and delicate. Cursive script takes a little of the strength away from the block characters, and makes the message gentler as a whole.

9. When you are happy with your sketch, reach for the paint. Take a black fibre/felt-tip pen for the words 'keep' and 'simple', and carefully draw along all the lines. Go along a line a second time if it seems too thin at first, as you want these words to be bolder than the cursive script.

10. Use a black fineliner for the 'it'. This lettering needs a steady hand, because most of it (apart from the dot on the 'i' and the line through the 't') should be written in one go. If you are not too sure, practise first on a piece of scrap paper. When you are ready, steadily draw along the lines. Once you are certain the lettering is fully dry, carefully rub out the pencil lines from your initial sketch.

This is how easy – and lovely – the combination of hand lettering and watercolour can be!

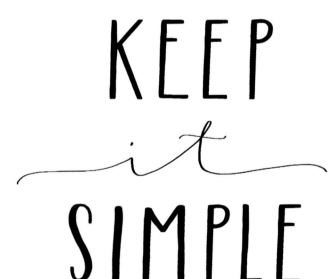

30

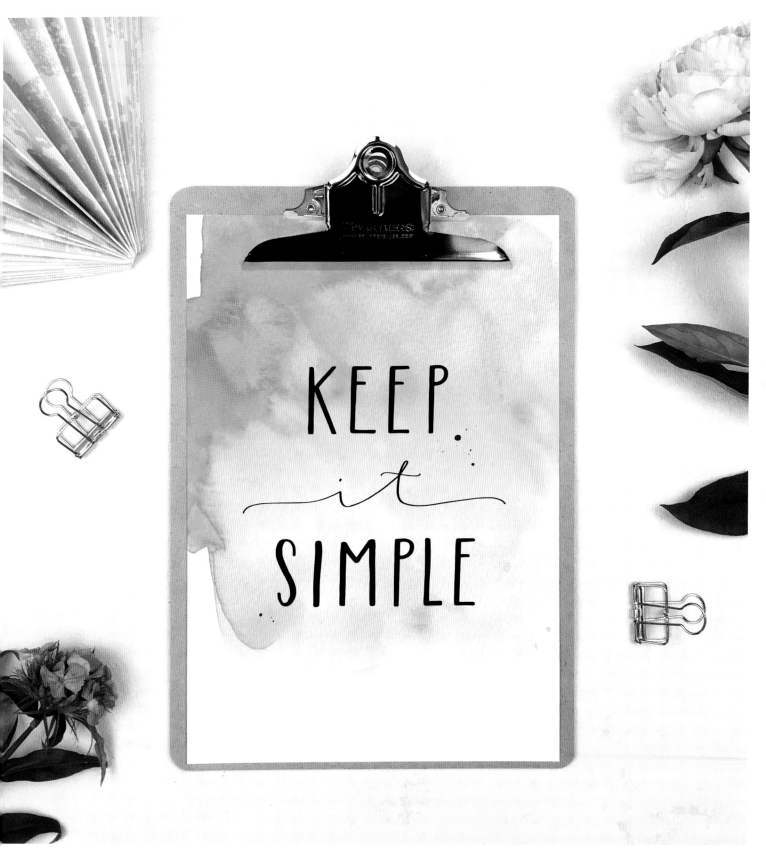

YOU MAKE EVERYTHING BETTER IN MY LIFE ▶

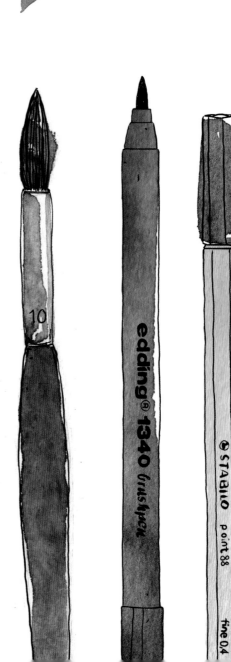

Who makes everything better in your life? This wreath is minimalist in style and therefore ideal for beginners, because it consists only of a single rose and a circle.

This motif doesn't take long to do and yet is extremely effective. It is perfect for a home-made greeting card or as a favourite saying to go on your living-room wall.

We used hot-pressed (smooth) A5 (5¾ x 8¼in) watercolour paper for this project. A tapered size 10 paint brush is suitable for this format. You can also use a smaller one, depending on how big you want the flower and leaves to be. Write the lettering with a fineliner and a brush pen. The smooth surface of the paper will be kind to your brush pen, and won't make it fray. You will also need a pot of water, a small pot or dish for mixing, an HB pencil, a ruler and an eraser. You may wish to have also a pair of compasses or round object to draw around.

Colour palette

1. Draw a large circle in pencil; this can be done freehand, or using a pair of compasses or a round object of the desired size as a template. Make sure that the circle is the same distance from the edge of the paper on the left and right. This will make the finished wreath more balanced.

2. Sketch the shape of the rose. You can make the flower as large and eye-catching as you like. Place it on the wreath, wherever you like. Here, we thought it looked nice at the bottom.

3. Add leaves on each side of the rose. Try to make both branches of leaves roughly the same length. Draw the leaves along the circle, using its line as a guide.

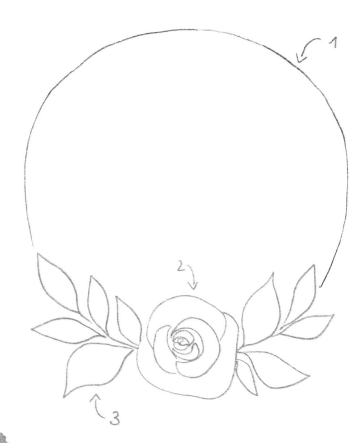

Tip: Whenever you are sketching, take care not to press down too hard on the pencil. Otherwise, there is a risk that the lines could dig into the surface of the paper and still be visible, even after you have rubbed them out.

Chapter 2 | Let's get started

4. When you are happy with your sketch, start mixing one shade of red and one of green. If you want the colours to look a little more natural together, add a little green to the red and vice versa. This will make the two colours more harmonious. Add tiny amounts of colour at a time, though – if the red gets too dark, you won't be able to lighten it again.

5. Now start on the rose. The petals of a rose make up a corolla that gradually becomes wider towards the outer edge. You can make use of this principle here. Start with painting the inside petals by arranging little half-moons in a circle. The centre of the rose should be very strong in colour. Continue to paint larger and larger half-moons around these, adding more water to your red mix with each outer petal.

Tip: Painting abstract flowers is a technique learnt through habit. Take some scrap paper, and keep practising these steps until you're happy with the results.

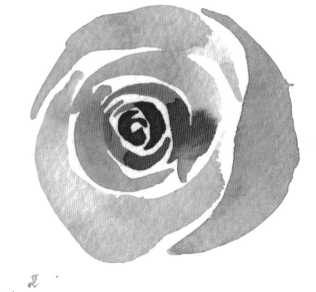

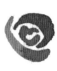

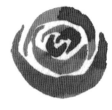

6. Now continue with the branches – again, it's a good idea at first to practise them on a scrap piece of paper. Start with the stem of one branch. You can paint it along the line of the circle. Add a few stalks here and there to make the whole branch look a little fuller. To finish, add leaves to the left and right. Repeat for the branch on the other side of the rose.

Tip: Of course, you can vary the shapes of the flower and leaves. You'll find some fabulous examples and ideas on pages 88 to 91, and 94 to 95.

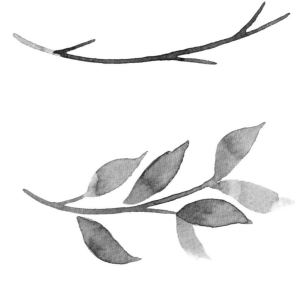

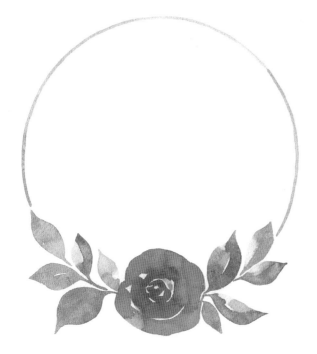

7. Paint the circle in the same green as the leaves. Take care to draw the circle line so that the ends are just short of the leaves – a tiny gap will give your illustrations a little air.

When the wreath is dry, move on to the lettering. We used the Ecoline brush pen in black here. It is easy to do larger lettering with it, and the effect of a lovely flow of ink is created all by itself.

8. Using the ruler and HB pencil, draw three horizontal lines inside the wreath and then add elongated rectangles around them where you want the words to go. This will ensure that you get the spaces right for the letters.

9. Using the HB pencil, write the words in sequence, and without pressing down too hard. You just want the bare bones of the letters to begin with.

10. Now take up your favourite brush pen and carefully write the words. Try to draw the letters with a flowing movement, and vary the pressure on the tip. If you're not too confident yet in using the brush pen, practise the exercises on pages 104 to 109 before you start your lettering.

11. If you make any minor mistakes, use a fineliner in the same colour to carefully go over the area once more.

12. Finally, once your lettering is dry, rub out the pencil lines from your initial sketch. You've completed the special message to your favourite person.

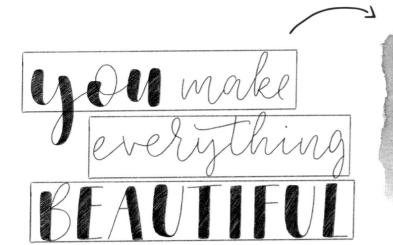

Tip: Try to keep your initial sketch simple. It's very tempting to play with lots of details, but that comes at the cost of time and spontaneity.

HOME IS WHERE MY CACTUS IS

We love cacti! Not just because they have the strongest will to survive, but also because they are green all year round and they remind us of the warm months of summer. Some of them even flower in lovely colours. Isn't that just amazing?

Cacti are actually quite trendy at the moment. You can see them everywhere – as art prints, on mugs or cushion covers, or varieties of the real thing sitting happily on window sills. They're also easy and quick to draw.

We made this project to measure 30 x 40cm (11¼ x 15¾in). As we use watercolours for both the illustration and for the lettering, we recommend using rough paper. Because of the large format, use a size 20 flat brush to paint the larger areas, and a size 6 round brush for the lettering and embellishments. You can also use a soft 4B pencil for the cactus spikes. As always, do the initial sketch using an HB pencil, a ruler and an eraser. You will also need a pot of water and a small pot or dish for mixing.

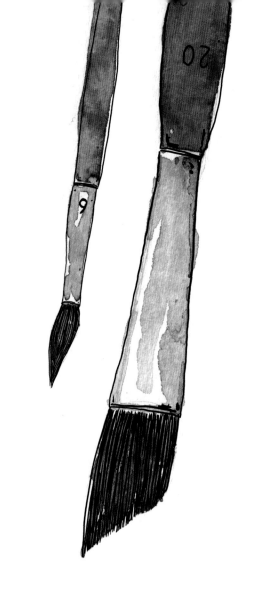

rough

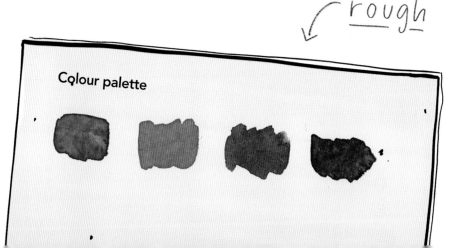

Colour palette

1. Start with a sketch outlining the plant pot and cactus. Both should be on the middle of the paper. If you divide the height of the paper into four, the plant pot should sit roughly in the bottom quarter. If you wish, use the finished picture on page 43 as a guide.

2. Now work on the pot, and lightly sketch the pattern that will appear on it. Your lettering will go on a sign that you will define in paint later on, so draw this in after you are happy with the pot and design. Bear in mind that the size of the sign will decide the size of your lettering at the end, so leave yourself plenty of space to work with.

Cacti come in lots of different shapes and sizes. Look at photos for inspiration. We've put a wall up on Pinterest for you with an abundance of cacti and succulents: pinterest.de/ mayandberry/kakteen

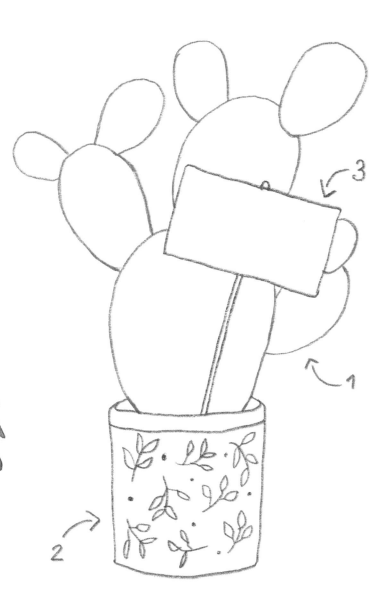

3. When you are happy with your sketch, you can begin to mix the paints for your design. Mix a lovely shade of green for the cactus and a complementary shade for the plant pot – we chose a cinnabar red. Also make a brown and grey for the sign – mix blue with slightly more red for the brown, and simply water down a black to create the grey.

4. Start by applying a soft base colour all over the surface of the cactus. You can make it very light in the first step by mixing plenty of water with your chosen green.

5. Lightly dot a darker shade of green all over the area, working from the bottom of the cactus to the top and letting the paint spread across the paper. Make sure that the areas that are in shadow are darker, and the ones where light would fall naturally are much paler. If a light area gets too dark, just take a cloth or kitchen paper and dab a little of the paint off while it is still wet. This will also make the highlight effect even stronger.

6. Allow your work to dry completely then paint the base colour of the plant pot with the red, thinned with lots of water. Again, leave to dry.

7. Start painting the leaf pattern on the plant pot with a stronger mix of red.

8. Use the brown for the stick of the sign and outline the white area in the grey.

9. Let it all dry completely. To finish, add little spikes all over the cactus, either in a soft pencil or a very dark shade of green. Space the spikes evenly across your cactus as this looks more natural.

Tip: Remember the paint will dull slightly as it dries and become lighter. So be brave, and work with a strong contrast.

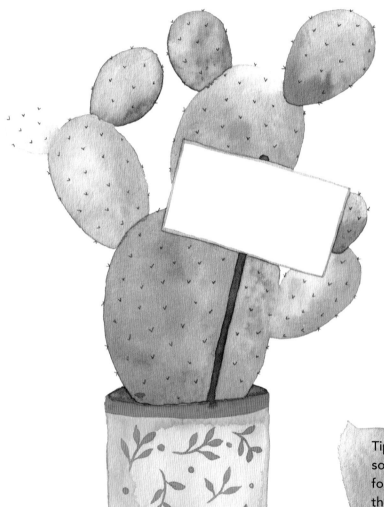

Brush lettering goes well with our cactus. We used a size 6 brush and Ecoline liquid watercolour in black, but other inks or regular watercolour paint will also do a good job.

10. Use the HB pencil and ruler to draw two lines on the paper within the sign.

11. Sketch each word in turn. You can use the sketch and final picture on pages 42 and 43 as a guide, if you wish. The sketch isn't quite so important when lettering with a brush, because the brush is a little unpredictable. Nevertheless, drawing the words here initially makes sure that everything is centred, and that the spaces within the sign are even.

Tip: Of course, you can change the style of some of the words. In this example, we opted for a basic, muted script so as not to reduce the impact of the illustration. You can find the alphabet for this on pages 106 to 109.

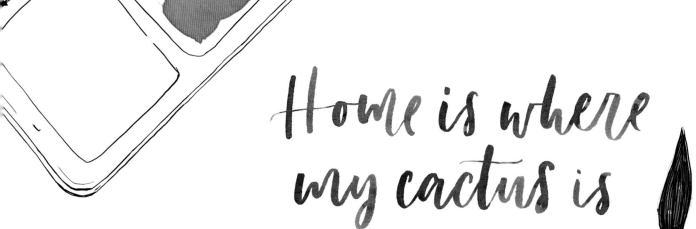

Home is where
my cactus is

12. Now to start painting your lettering. First, moisten the brush and add a little more black paint to your grey mix in your mixing pot or dish. This will strengthen the colour a little, and make it bit thicker and darker in colour.

If you're not sure how to begin painting your words, practise the lettering a few times on a small piece of watercolour paper. Remember to increase the pressure on the brush on your downward lines. For the upward lines, just let the brush move lightly over the surface of the paper. The exercises on pages 104 to 109 will help you perfect this flowing hand movement.

13. Dip your brush in the black paint, and carefully paint over your sketched letters. Don't worry if the same letters look a little different; this is part of the charm of brush lettering.

14. Allow your words to dry before you carefully rub out the pencil line.

Now you can thank your loyal cacti for the lovely feelings of summer they provide with this pretty art print.

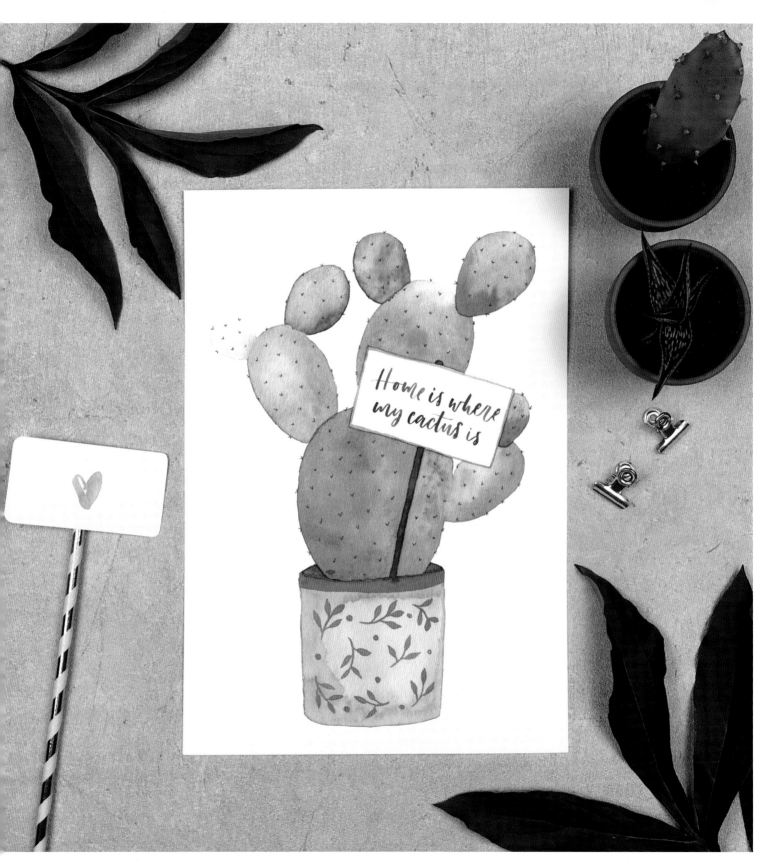

THANK YOU FOR THE FLOWERS

Do you know the 'Flower Duet' by Delibes? We found ourselves humming it as we collected ideas for this book, so it's hardly surprising that flowers should be found somewhere in it. This very pretty motif works both as a thank-you card if someone sends you flowers, as well as in a frame on the wall. A pot of pretty flowers instantly makes a home look lovelier.

We have made this art print on watercolour paper measuring 30 x 40cm (11¾ x 15¾in). The paper we've chosen is rough, because the lettering is written with watercolour paint. The best paint brush to use for the letters is a size 6. For the illustration, we recommend brush sizes 6 and 20. As always, do the sketch using an HB pencil, a ruler and an eraser. You will also need a pot of water and a small pot or dish for mixing.

rough

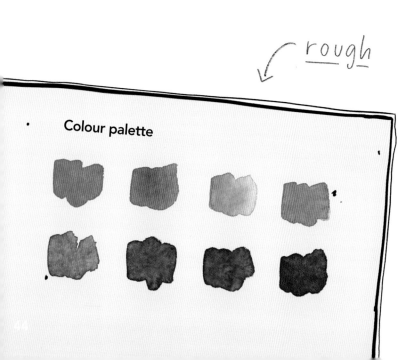

Colour palette

1. As always, start with a sketch. For this design, you might want to make it a little more detailed than before. Divide your page into three horizontal sections and draw the pot in the bottom third. As the bouquet should be lovely and blooming, start to indicate the rough contour of the finished bouquet with an oval.

2. Draw the large flowers next. Try to space them evenly throughout the bouquet.

3. Think about other flowers and floral varieties (for example, berry stems and grasses) that would look good in the bouquet, and sketch them in.

4. When you are satisfied with the rough arrangement, fill the remaining gaps with large and small leaves.

Tip: Details will make your bouquet come alive. Add tiny buds or berries to your illustration. You could look at your old school biology books for inspiration.

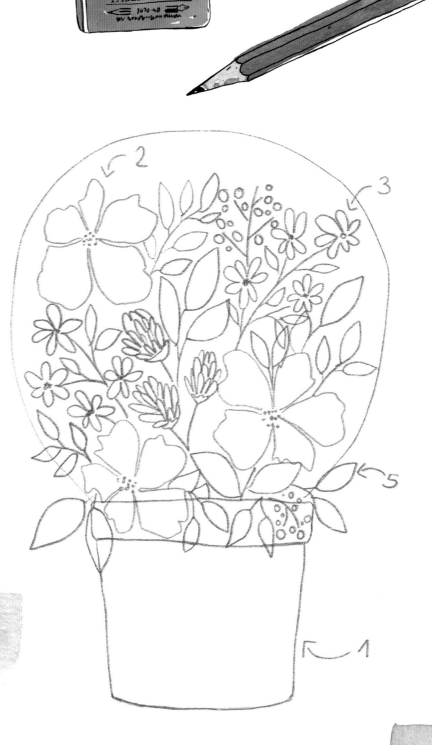

5. When your sketch is finished, you can get out the paints. Create a pretty colour palette. We've worked with just a few strong colours but made a variety of shades with them to make the flower arrangement more three-dimensional. We used three shades of green, and four each of red and yellow.

6. Start with the large flowers at the front of the bouquet, using the size 20 brush. You can make them really bold and eye-catching. Paint them as jagged loops around an invisible centre, and then add the stamen last in another colour. Then, take the smaller brush and paint in the smaller flowers and berries, again using bright colours.

Lastly, paint the stems and leaves. For the few large leaves in the background use only a very light shade of green; this creates the impression that they are further away.

Tip: If you want to overlay leaves, let your painting dry fully after each step. You can then paint several layers without the colours running.

7. To finish, paint the outline of the pot in light grey. Shading the underside of the rim around the pot will make your illustration look more sculptural.

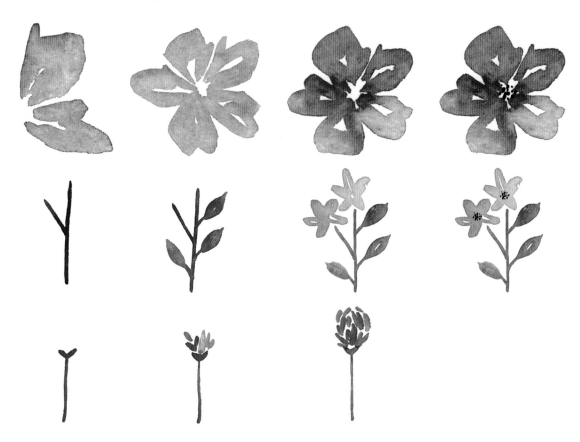

As the illustration is the focal point in this motif, we decided to place the wording on the pot. You can put them somewhere else, though, if that works better. We used the brush lettering technique (see page 15), a size 6 brush and black watercolour paint.

8. Lightly draw some lines within the pot with a ruler and HB pencil. How you place the words, and how large they are, will be determined by the shape of your pot.

9. Now sketch the lettering, word by word, with your pencil. We used a fairly neutral style of script because we wanted the focus to be on the flowers. However, we decided to highlight the main words 'thank you' and 'flowers' by making them a little larger in size.

Tip: You will gradually develop your own writing style. Practice and patience make perfect.

thank you for the flowers

10. Take up your brush and pick up some of the black watercolour paint. Of course, you can use another colour if you prefer. Moisten the brush and apply a little paint to a mixing palette. Add a few drops of water with your brush to make the black a little more watery.

You might want to practise the lettering on a scrap piece of watercolour paper first, before tackling the illustration. As you paint, remember to increase the pressure on the brush on your downward lines. For the upward lines, let the brush glide very gently over the paper's surface. The exercises on pages 104 to 105 will help you perfect this flowing hand movement.

11. Dip your brush in the thinned watercolour paint, and carefully paint over the sketched words.

12. Allow your words to dry completely before you carefully rub out the pencil lines.

And there you have your cheerful still-life with flowers! Try painting this project with other types of flowers and pot shapes. See pages 88 to 90, and page 93, for more inspiration.

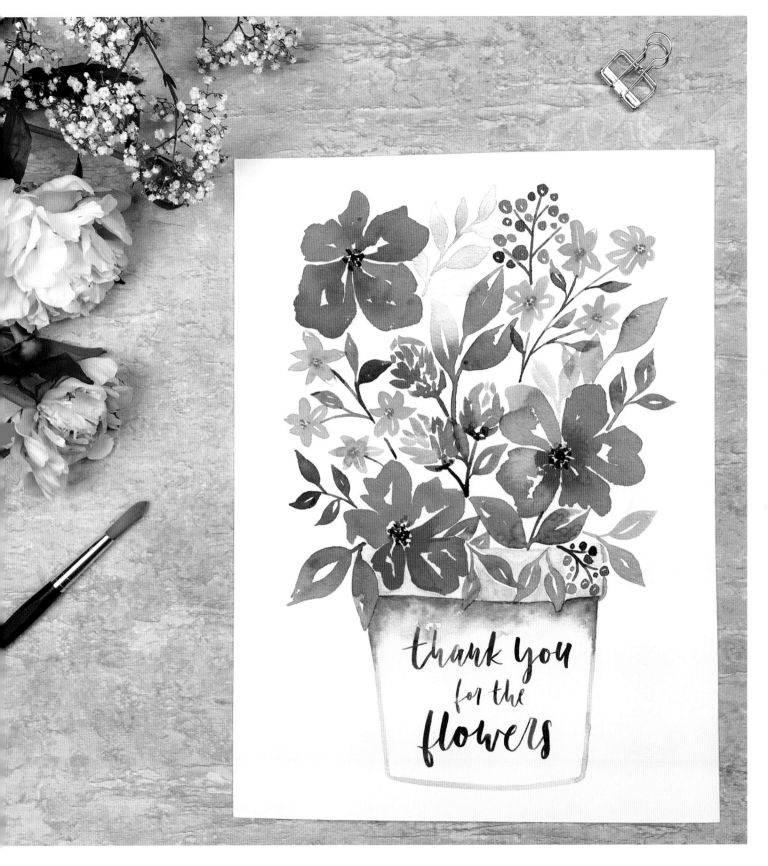

KEEP YOUR COOL

As well as flowers, there's something else we always have to have in our creative studio: ice lollies! Winter or summer, it's always time for an ice lolly. Our favourite is home-made berry lollies. Want to try them? It's really easy: you need natural berry juice, of course, with a few whole berries mixed in. Put everything in some ice moulds, pop them in the freezer – and done! To remind us of our favourite treat, we have this art print hanging in our kitchen.

This project is perfect for playing with the wash technique (see also page 22), and demonstrates how easy it is to make little illustrations for your designs. With a few little tips and tricks, an uncomplicated form can be turned into an individual work of art.

We used rough A4 (8¼ x 11¾in) watercolour paper here. You should use a size 10 paint brush for the illustration and a size 6 brush for the lettering. As always, use an HB pencil, a ruler and an eraser for the sketch. You will also need a pot of water and a small pot or dish for mixing.

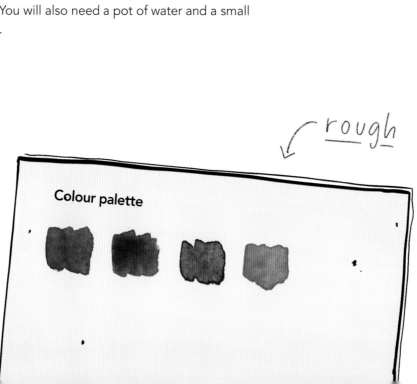

rough

Colour palette

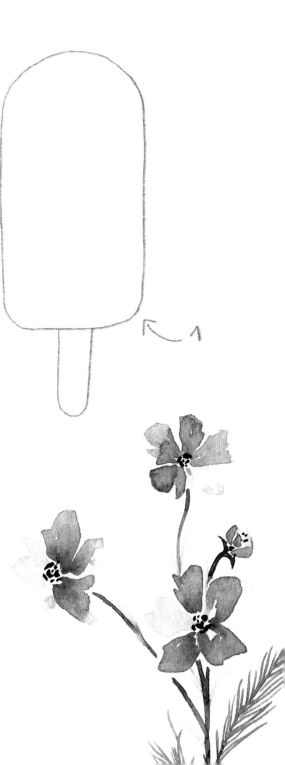

1. Sketch a rectangle approximately in the middle of the paper. Round the top corners generously to make a typical ice lolly shape. Add the stick at the bottom.

2. Choose two colours, remembering they will run into each other. It's up to you to decide whether you want a subtle colour wash, such as blue and purple, or something louder like red and green. We opted for a blue and purple version.

Tip: This easy illustration is also ideal for smaller formats, such as postcards. In this case, use a smaller paint brush for the lettering, such as a size 2.

3. Wet the paper within your lolly shape using a clean brush and clear water. The area should be well moistened. Then, grab your paints and in your mixing pot or dish thin the lighter of your two chosen colours – the blue in this case – with water. This paler colour will be used as the base coat. Carefully run the brush along the edges of your lolly shape. Wash your brush, then take up the main blue and dab it into your still wet base colour, working from the bottom edge of your lolly up to about one-third of the area.

4. Rinse the brush completely and dry it before you start adding your second colour. We used purple. With this shade dab into the sides and head of your lolly, working from the top down to about one-third of the area.

Tip: Don't rush this wash; give the paints time to develop. Blended colour washes are often created by chance, without us influencing them. If you're not sure, then experiment first with a few washes in different colours on a scrap piece of watercolour paper.

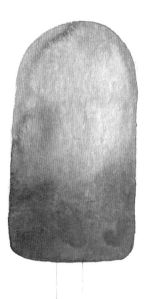
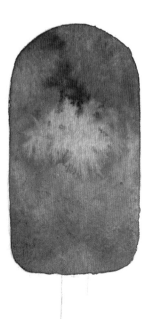

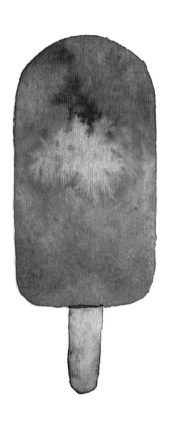

7. Sketch some rectangles around the lines in the places where you want the individual words to go. Then, draw the words in the rectangles.

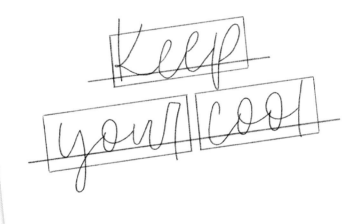

5. Your ice lolly now has to dry well. Afterwards, finish by painting the stick in a light brown made by mixing blue with slightly more red, and thinning it with plenty of water.

We recommend doing the wording as brush lettering, using a paint brush and watercolour paint. This ice lolly is made almost entirely of water, so we felt it made sense to use watercolour paint for the lettering.

6. Draw two horizontal pencil lines under your illustration. They should be positioned centrally underneath each other, on the bottom third of the paper. Leave plenty of space between the lines to give yourself enough room to work.

53

8. Take up a brush and some watercolour paint. We chose a pink this time. Of course, you can choose any colour you like. Moisten the brush, and apply a little paint to your mixing pot or dish. Add a few drops of water with your brush to make the pink a little more watery.

Practise the lettering a few times first on a scrap piece of watercolour paper. Remember to increase the pressure on the brush on your downward lines. For the upward lines, let the brush glide very gently over the paper's surface. The exercises on pages 104 to 109 will help you perfect this hand movement.

9. Dip your brush in the thinned watercolour paint, and carefully paint over all the sketched words.

10. Wait until everything is completely dry before you rub out the pencil lines.

Your art print is ready – and is sure to leave you wanting to enjoy the real thing.

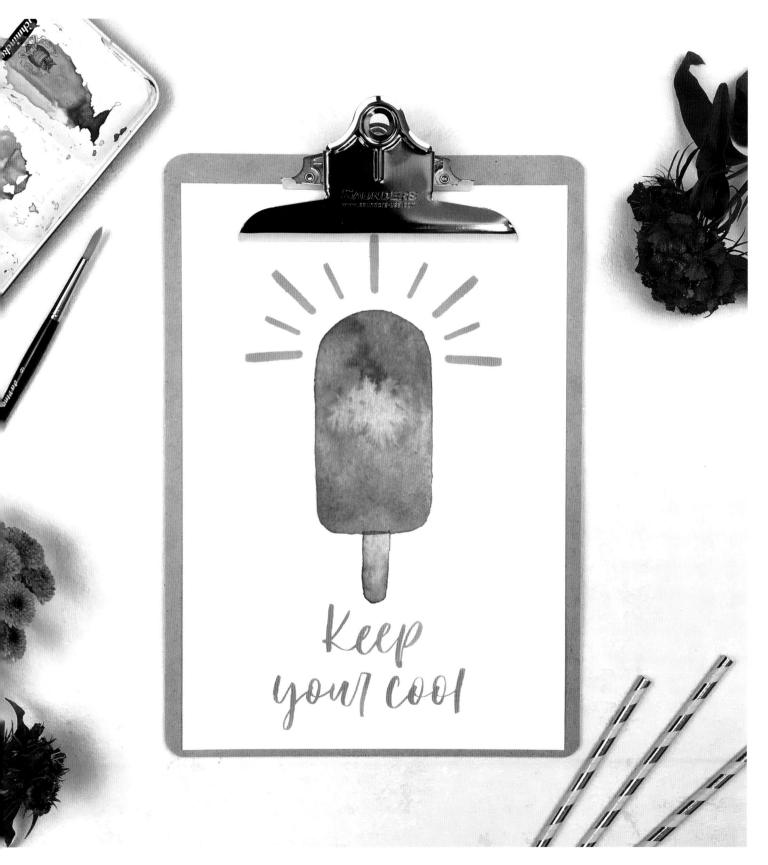

MY LOVELY GARDEN

Whether working with a spade and wheelbarrow, or relaxing on a lounger with a lemonade, for many people their garden is a place of refuge and pure relaxation. Sometimes, even a small balcony garden can be enough to make you happy – our studio has a roof terrace that we've filled with lots of flowers and plants. This art print is to remind you of your blooming garden or balcony all year round.

For this design, we chose to use rough A4 (8¼ x 11¾in) watercolour paper. A size 10 paint brush is best for the illustration. For the wording, use a fineliner and a fibre/felt-tip pen. As always, use an HB pencil, a ruler and an eraser for the sketch. You will also need a pot of water and small pot or dish for mixing the paint.

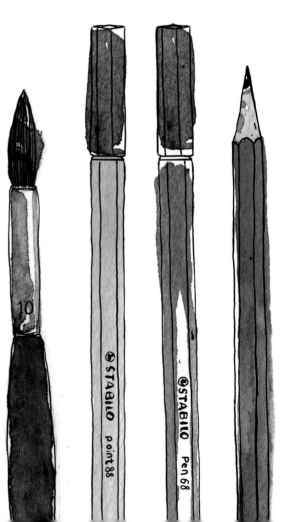

Colour palette

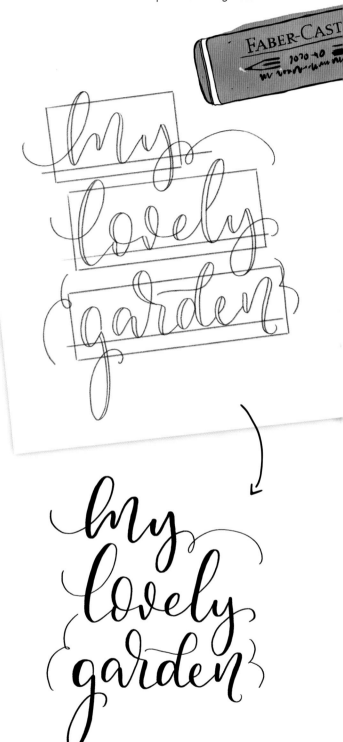

For this project, we'll work in the opposite sequence and start with the lettering. The idea is that the lemons and leaves will later wrap around the wording like a pattern.

1. Use the pencil and ruler to draw three horizontal lines. The lines should be positioned in the middle of the paper.

2. Draw three rectangles around these lines in the places where you want the words to go.

3. Carefully draw the words in the rectangles. We've used the alphabet on page 97 for our lettering. Leave the flourishes out for now.

4. Once you have sketched the main message, it is time to add those flourishes. Make use of the white spaces in between and around the words, and make the swirls nice and round.

5. When you are happy with your sketch, you can start to draw over your letters with ink. Carefully go over all the lines in fineliner.

6. This next step uses the 'faux calligraphy' technique, described in detail on page 13. Double the downward lines of the individual letters using the fineliner. This creates a lovely contrast between the thick and thin lines.

7. To finish, fill in the remaining white spaces. You can do this with the fineliner or your fibre/felt-tip pen. Once dry, carefully rub out the pencil lines from your initial sketch.

Ensure that your lettering is completely dry before you start sketching and painting the lemons.

8. Draw approximately four large oval shapes around the wording. Add a stem to each lemon, with one or two leaves at the end.

9. Fill in the remaining gaps with individual leaves. Make some of the leaves face up and some down, as this creates a more balanced pattern.

Tip: A pattern looks more harmonious and structured if the individual objects in it are roughly equidistant from one another. You can make sure of this in your initial sketch.

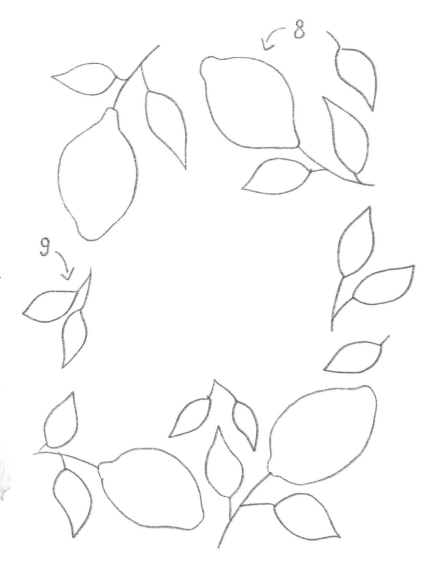

10. When you are happy with the positioning of the lemons and leaves in your sketch, you can start selecting the colours. Choose one shade of yellow, one of orange and one of green. In your small mixing pot or dish, thin the yellow well with plenty of water; this will be the base colour for the lemons.

11. Colour the first oval entirely in the pale yellow. Then, take up a little orange with your brush and lightly dot it along the edges. The colour will now run, creating a three-dimensional effect. You can repeat this process until the colour of the lemon is strong enough.

12. When the paint has started to dry, add a few orange dots here and there in the upper and lower sections of the lemon. This imitates the large pores on the fruit, and looks more natural.

13. Paint the other lemons in the same way.

Tip: Watercolour paints lighten as they dry and lose their luminosity. For this reason, don't be sparing with the paints if you want stronger colours in your illustrations.

You'll find further inspiration for gardens and balconies at: pinterest.de/mayand berry/mygarden

14. Let the fruit dry completely, and then finish off your pattern by painting in the stems and leaves with the green colour. We have used a muted shade, but by all means use one that is stronger. Start by painting the line for the stems with a steady hand. The leaves can then be shaped from two crescent-moon shapes, which makes them nicely full and round.

This art print always reminds us of summer, which is why we have put it in a particularly lovely spot in our studio.

Tip: It is effective to leave a few unpainted areas on the lemons and leaves. It mimics light reflections, which lightens the illustration and brings your work of art to life.

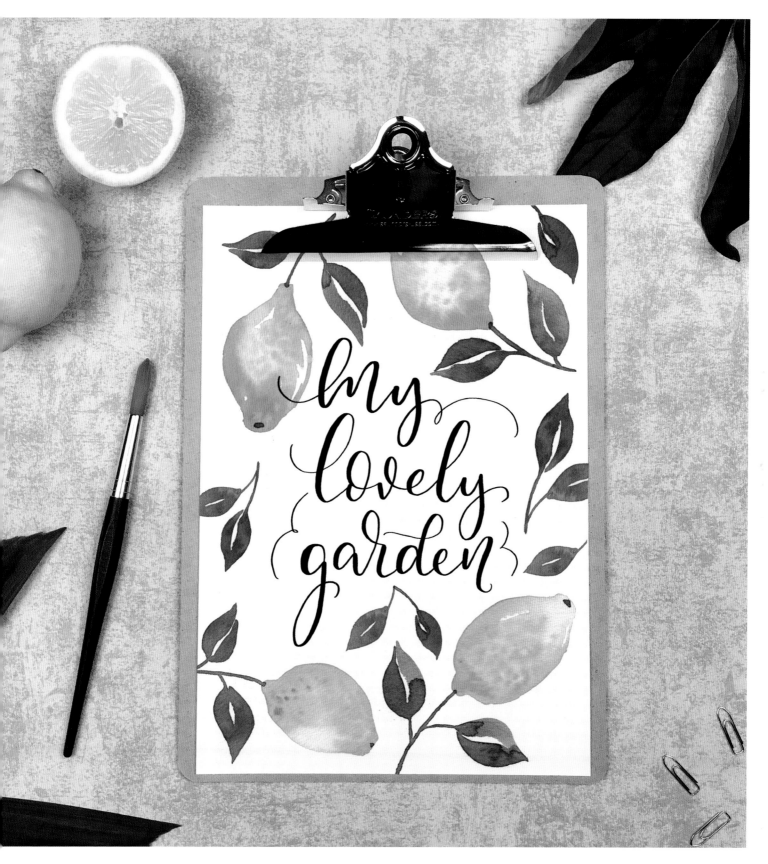

FOR YOU

Who still writes and sends letters today? Hardly anyone, sadly… and yet it's so nice to receive a letter from a loved one. There is so much more thought and effort in a letter than in an email or WhatsApp message. So if we're not sending letters, let's at least paint a few.

In this project, the focus is on the illustration. The motif fits perfectly on A5 (5¾ x 8¼in) watercolour paper. Use a fairly smooth paper though – cold-pressed is ideal – so your brush pen doesn't suffer too much. All you need for the lettering is your favourite brush pen; for the illustration, we recommend a size 8 paint brush. As always, do the sketch using an HB pencil, a ruler and an eraser. You will also need a pot of water and a small pot or dish for mixing.

Colour palette

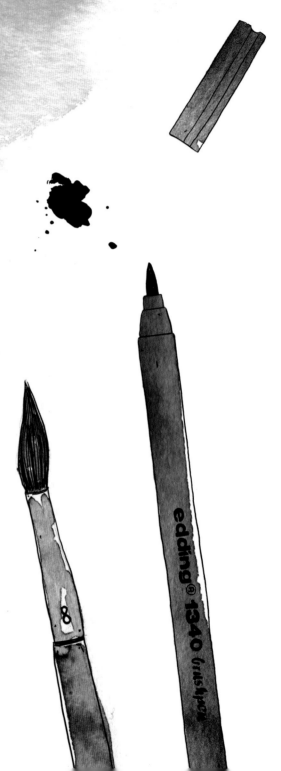

Incidentally, this art print will also work well on a pop-up card!

Tip: It's fine if the flowers are all of different sizes. One could even be a bud. This will make the illustration more natural.

1. First, mark the approximate size of the motif in your sketch. Leaving a space around your motif will give it more balance and air on the paper. Allowing for a small margin around your design, divide your paper into three sections. In the bottom third, mark the outline of the main envelope and then draw in the folds. In the middle third, draw an open envelope flap.

2. Next, draw two or three large flowers within the middle third of your paper. Use the lines above and below as a guide, but don't be afraid to let your flowers edge into the other areas if you wish.

3. Fill the gaps around your flowers with large leaves and stems. You could let some of the leaves hang over the edge of the envelope, to make your design more realistic.

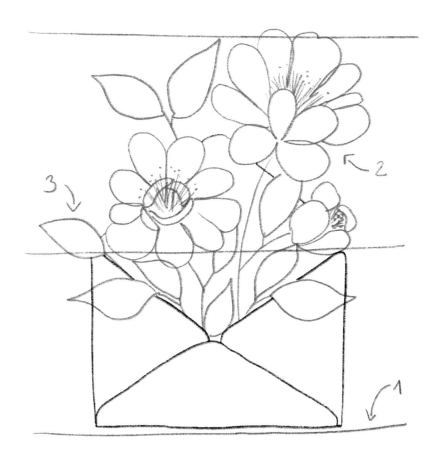

4. When you are satisfied with the position and arrangement of your motif, you can start on the painting. Select one shade of pink and one of green. In your mixing pot or dish, thin the pink with plenty of water.

5. Paint the flowers with the light pink. For the centres, paint a corolla as for the roses before (see page 34), and then add jagged loops for the larger petals around it. Then, take up a little of the original pink paint with your brush, and dab it along the bottoms of some of the petals in the centre; this will make the inner part of the flower darker. Repeat this step until you are happy with the colours in your flowers. Let everything dry well.

6. Next, start on the leaves. You'll see they have a white line down the middle to simulate a spot of light on the leaf. To create this effect, it's easier if you divide the leaf into two crescent-moon shapes.

Tip: If your brush is big enough, you can also paint these two moon shapes in a single brush stroke. Just make sure that the brush is moist when painting, or this will cause dry marks on the paper.

7. Mix a brown from a little pink and some of the green. Add short, thin lines from the base of the flowers with the small brush and paint down into the envelope. Paint them at different lengths, and finish your flowers with a couple of dots for the stamens.

8. Finally, paint along the outlines of the envelope in a light grey, made by mixing black paint with plenty of water.

That's the main part done. Now you can complete the pretty floral envelope with some lettering. For this design, we used the alphabet on pages 106 to 109. As the illustration is the primary focus in this project, we have chosen a simple 'for you' for the wording. A little heart to go underneath it won't do any harm.

9. Use a ruler to draw a horizontal line above the flowers, leaving a little space between it and the top-third guiding line to give your message some air.

10. Draw two rectangles around the line in the places where you want the words to go. This will make sure your words sit in the right place.

11. Pencil the two words lightly, and finish it off neatly with your heart. The script style is simple for this design, so there is no need to add any flourishes.

If you need further
ideas and inspiration
for some lovely hand-
written letters, look at our
Pinterest wall:
pinterest.de/mayand
berry/loveletters

12. Take up your favourite brush pen, and carefully write the words. Draw the letters with flowing movements, and vary the pressure on the tip. Remember that the downward strokes should be thicker. If you're not too confident yet in using the brush pen, we are sure you will find the exercises on pages 104 to 109 helpful.

13. Correct any minor mistakes with a fineliner in the same colour, and carefully go over the area once more.

14. Once your lettering is dry, rub out the pencil lines from your sketch – and you have a lovingly crafted message for a very special person in your life.

BE WILD

Adventures are great! They expand our horizons, make us more creative, open up new paths – you can keep on adding to the list of benefits. It is particularly important for creative people to gather as many experiences and impressions of the world as possible, as only then can we keep creating new things. Think unconventionally sometimes and 'be wild' – a lovely motto for us, and one that we like to keep reminding ourselves of.

For this project, we chose rough watercolour paper in size A3 (11¾ x 16¼in). The large colour wash in the background is easy to achieve with a size 20 paint brush, and we used a round size 10 brush for the green leaves. For the lettering, use a size 8 brush. As before, you'll need an HB pencil, a ruler, an eraser, a pot of water and a small pot or dish for mixing the paints.

rough

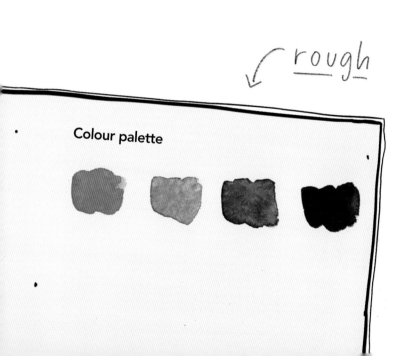

Colour palette

This art print isn't really difficult, and yet is highly effective. That's because of the variety of different techniques used for it.

1. First, try your hand at achieving a pretty wash for your background. You can find more details on how to do this on pages 28 to 29. Here, we opted for one shade of pink and one in blue. Make sure that the background isn't painted too dark, otherwise you won't see the leaves at the sides or the lettering so well later on. For our design, we made very light washes with the pink and blue by mixing them with plenty of water. Wet the whole of the paper. Then, paint the pink wash into the bottom left-hand corner and lightly dab this colour outwards. Repeat this process with the blue in the top right-hand corner. When you are happy with your background, leave it to dry thoroughly.

2. Use your HB pencil to draw a few leaves at the edges of the paper, as if they're reaching into the picture. Try to create a nice balance with the leaves. If there are three branches on the left, then draw either three of the same size or two larger ones on the right. This will give the design structure, and create a sense of harmony.

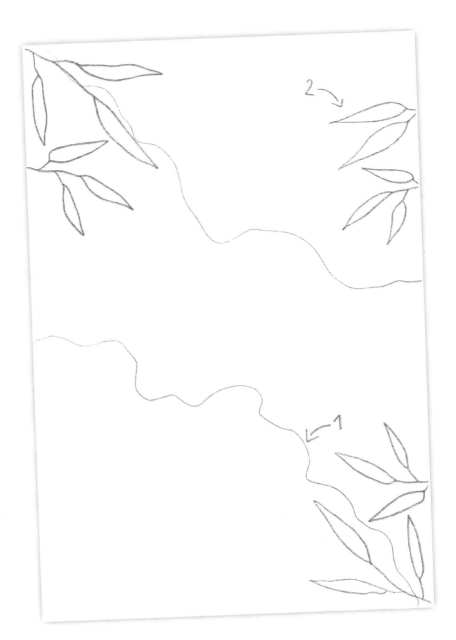

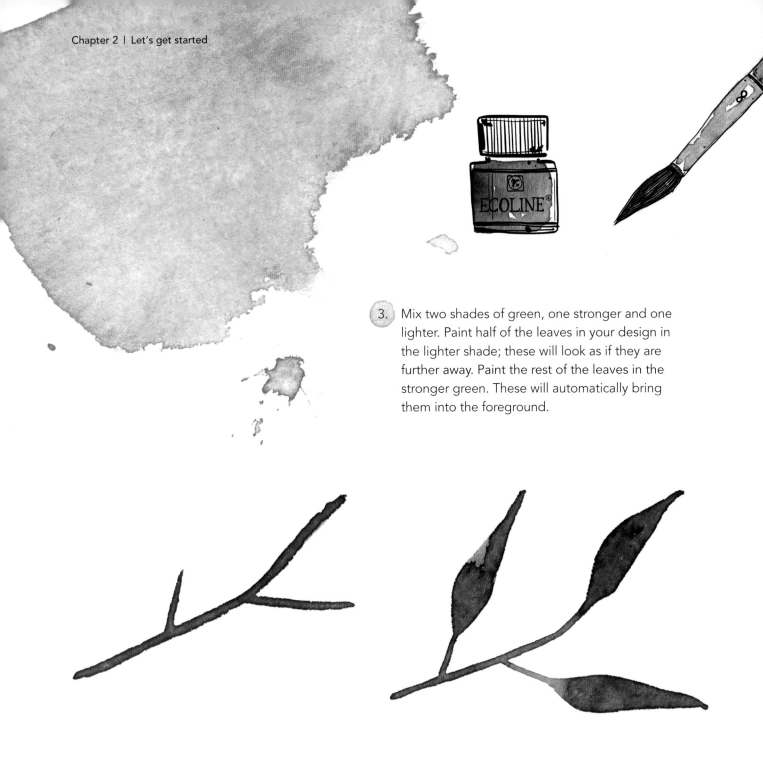

3. Mix two shades of green, one stronger and one lighter. Paint half of the leaves in your design in the lighter shade; these will look as if they are further away. Paint the rest of the leaves in the stronger green. These will automatically bring them into the foreground.

The short message was created using the brush lettering technique (see page 15), a size 8 brush and black watercolour paint. We chose cursive lettering here, but of course you can also use block letters. The main thing is that the writing is large enough, and positioned in the centre of the paper.

4. Draw two pencil lines, one above the other, in the middle of the paper. Don't make them too close together, so you have enough space to paint the letters – they're going to be nice and big.

5. Now draw two large rectangles around these lines, one above the other. This is where the words will go.

6. Now sketch the two words 'Be' and 'wild' inside the boxes.

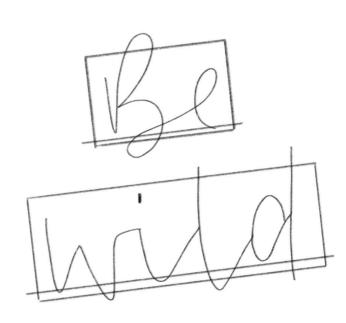

7. Now it's time for the brush and paint. You can, of course, use a different colour if you don't like the black. Moisten the brush, and add a little black to your mixing pot or dish. Add a few drops of water with the brush to make the black a little more watery.

8. You can practise the lettering a few times on a scrap piece of watercolour paper first, before tackling the illustration. Remember to increase the pressure on the brush on your downward lines. For the upward lines, let the brush glide very gently over the paper's surface. The exercises on pages 104 to 105 could be useful to help you perfect this flowing hand movement. Dip your brush in the thinned black watercolour paint, and carefully paint the two words.

9. Allow your words to dry fully and then carefully rub out the pencil lines.

10. To finish, pick up a little of the thinned black paint with your brush and gently flick it over the paper once or twice to create delicate flecks. Leave to dry.

And now you have your daily reminder to leave your comfort zone more often and throw yourself into a wild life.

Be wild

BECAUSE YOU'RE THE BEST

There are sure to be several people in your life who make you very happy. And you can never tell someone you care for too many times how wonderful they are. It doesn't have to be a particular occasion – even a card with a pretty bunch of flowers on it is sure to make the recipient smile.

For this project, we have chosen rough A5 (5¾ x 8¼in) watercolour paper. We suggest paint brush sizes 6 and 8 for the flowers. A fineliner is all you require for the wording. Draw your initial sketch with an HB pencil, a ruler and an eraser, and have a pot of water and a small pot or dish on hand for mixing the colours.

This project might look a little challenging at first, but if you approach it step by step, the result will be an absolutely enchanting work of art.

You will find plenty of inspiration and lots of templates of lovely bouquets at: pinterest.de/mayand berry/Blumenstrauß

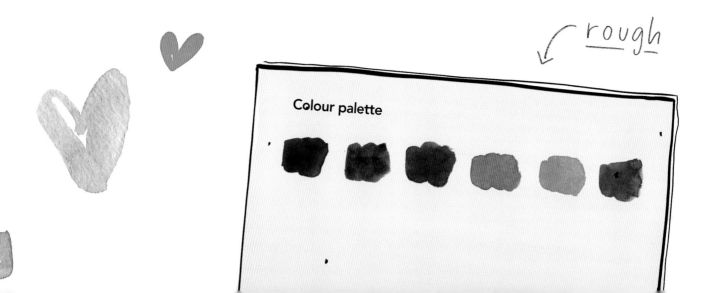

rough

Colour palette

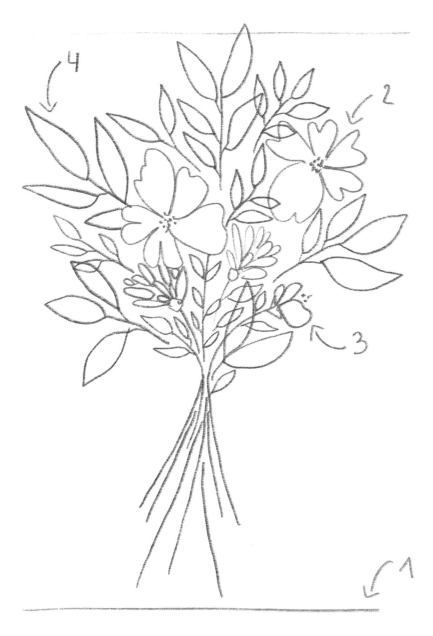

1. As the focus here is on the illustration, the bouquet should take up about 80 per cent of the paper. Lightly mark the top and bottom of the bouquet with your HB pencil and ruler. Take care to leave space below your bouquet for your message later on.

2. Start by drawing in the large flowers. Arrange them evenly in the bouquet, and don't put them all at the same height. After all, the flowers in a real bouquet are usually all of different lengths.

3. To make the bouquet varied and colourful, draw a few smaller flowers next to the large ones.

4. Fill the gaps between them with both large and small leaves.

5. When you have finished the sketch, you can make a colour scheme and prepare your mixes. You can find out more about this on page 25. A soft, pale shade is lovely for the large leaves, as this pushes them into the background and brings forward the flowers, showing them to their very best.

6. Now paint in the foreground parts of your bouquet with your strongest colours – these will be your flowers. For advice on how you may wish to paint your flowers, please see pages 46 and 64. Then, continue with the leaves around the centre of your bouquet. You can tone down these colours a little, using more muted shades and thinning them with water. Finally, paint the large leaves at the back in your palest shades. The different colour intensities will make the bouquet look more natural, and create the illusion of depth.

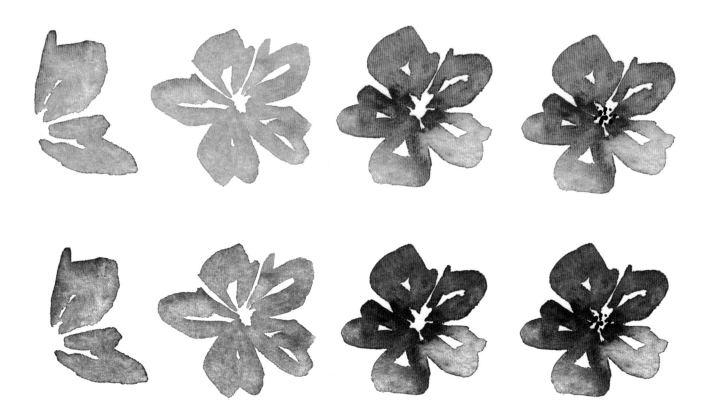

Tip: If you want the bouquet to be fuller and wilder, you can lay more flowers and leaves on top of one another. For this, you should work backwards and start with the light-coloured leaves at the back. Let them dry well and paint the stronger colours over the top.

7. Finally, add the stems at the bottom of the bouquet.

Tip: A few little buds here and there will give the illustration a natural look. You can also add them later to fill any gaps or to create a balance if the composition seems off.

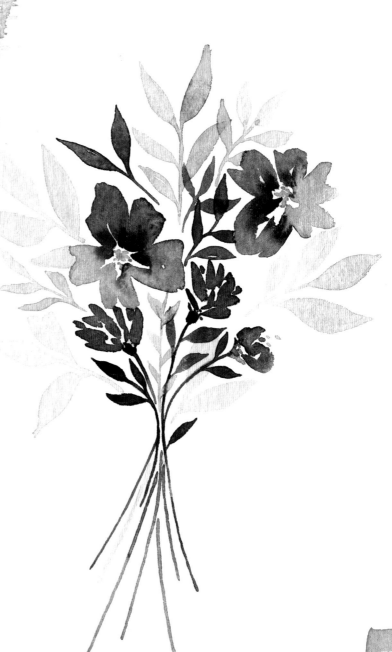

77

In this design, the focus is not on the lettering; the message simply reinforces the illustration. Why flowers? Because you're the best! We drew the wording in fineliner, using a cursive script. You can find the full alphabet for it on page 102. This script takes up little space and looks very elegant, without stealing too much attention from the illustration.

8. Use a ruler to draw a horizontal line under the bouquet. Take care to leave a gap of at least 2cm (¾in) from the bottom edge of your paper. Draw a rectangle around the line, to help you place your lettering correctly.

9. Sketch the message word by word using clean, unbroken lines. Try to write exactly on the ruler line to keep the wording neat.

10. Add flourishes at the beginning and end of the lettering. They can be as long as you like.

11. Now it's time for the fineliner. We used one with a thickness of 0.05mm. Carefully draw over the lines of your sketch. You need a steady hand and a sharp eye. Lift the pen just before each letter if you find that helps.

12. Usually, cursive script looks great as it is without further embellishment. In this case, we drew over the downward lines ('descents') again to create a little more contrast to the thin upward lines.

13. Allow the fineliner ink to dry completely before you rub out the sketch. Voilà, here it is – a bouquet of flowers for the very special people in your life.

because you're the best

Tip: For this step, it helps if you lift the pen as little as possible. Picture a rope that is straightened out and then use that image of the layered rope to shape each individual letter. Leave plenty of space between each letter, and make the letters quite small.

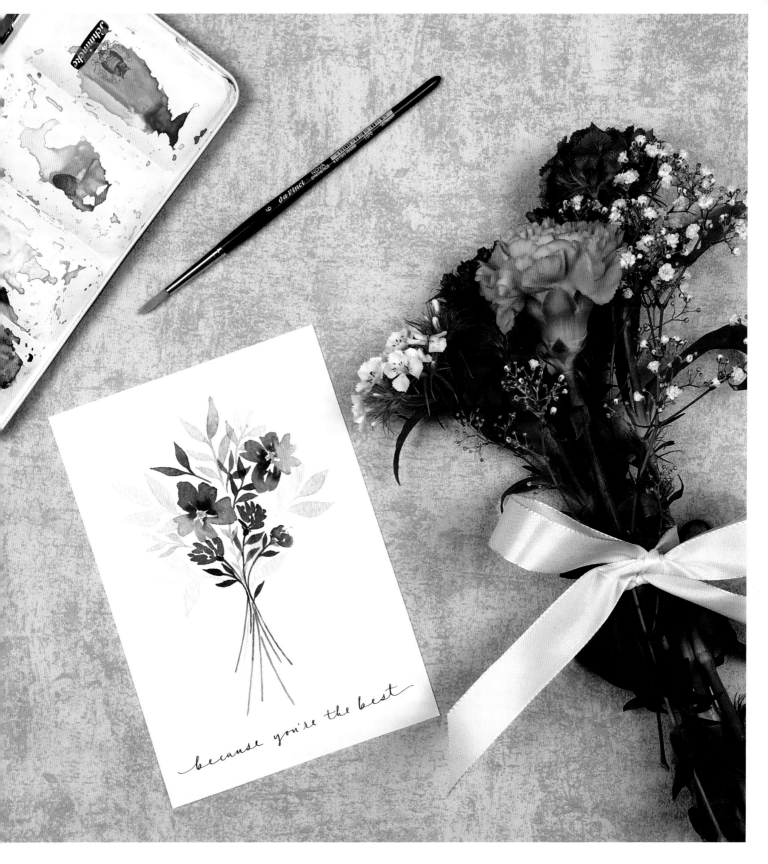

because you're the best

NO RAIN NO FLOWERS

Even though sunny weather is the greatest gift in everyday life, we also need to have rain so that our beloved flowers survive. We can say, then, that grey weather isn't so bad! This art print is perfect for rainy days, and – if you're anything like us – will help you to remember the good things when there are stormy skies.

We painted this art print on rough A4 (8¼ x 11¾in) watercolour paper. You can alternate between brush sizes 6 and 8 for the various flowers. In this example, we did the lettering with a large water brush pen. As always, design the sketch with an HB pencil, a ruler and an eraser. You will also need a pot of water, and a small pot or dish for mixing.

Surround the lettering with lots of different flowers and leaves to suit the wording. Decide yourself how colourful and full you want the frame to be.

A water brush is a brush with synthetic bristles that holds liquid paint for effortless watercolour hand lettering. The reservoir inside is easy to fill with water or paint, and you then gently squeeze the brush to wet the bristles. Water brushes have the same characteristics as an ordinary paint brush, but they give you far more control. You can write a word in one go, without having to keep stopping to take up more paint with your brush. They're also really easy to carry around with you.

Colour palette

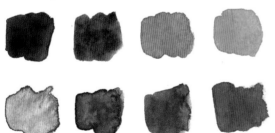

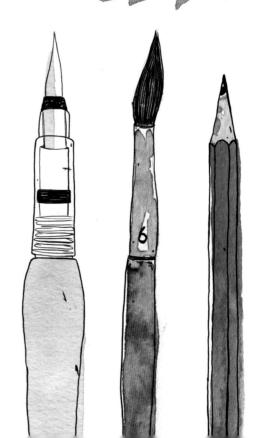

1. As always, start with a sketch. For this design, it might help if you prepare a highly detailed sketch beforehand to help you work out the overall composition. Start with the biggest flowers, as these will be the main focus of your design. Arrange them equidistant to one another along the edge of the paper.

2. Next, place leaves and stems around the large flowers. Also add small, filigree leaves to fill some of the gaps.

3. Lots of little buds, berries and flowers will make your illustration more playful and livelier. Add these to some of the leaves and flowers and in the remaining gaps.

Tip: If you decide to place your lettering in the centre of your piece of paper, make the illustration at the top and bottom edges a little more lavish. This will achieve a more balanced result later on.

4. Mix a few shades of purple, blue and green in your pot or dish. When you are using so many different colours, it is a good idea to make a colour scheme with little boxes (see page 25). This will enable you to see immediately if the colours go with one another.

5. Now to add your main flowers. Paint in the lighter shades first and then touch in the darker colours; this creates depth and will make your flowers look prettier. For our illustration, we primed the flower in a light shade of purple and then added a little dark blue to the bottom of the bud.

6. The leaf transparency should be varied to create more dimension in your design. Start with the leaves in the background and paint them in the lightest shades. These will need to dry well before you paint in the darker ones. For these darker leaves in the foreground, layer the lighter and darker shades while they are still wet to make them look three-dimensional.

7. Finally, add the berries, buds and little flowers. You can make the berries quite minimal: draw a simple stem with the brush, and arrange the berries around it. They don't have to be attached to the stem; a bit of a gap will add a lightness to the motif. Arrange everything as evenly as you can, so the frame looks balanced.

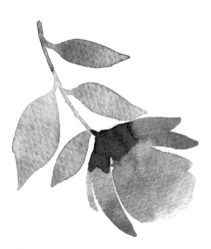

Tip: At some point, you'll find you've been staring at your paper for so long that you can no longer decide what looks good and what doesn't! It becomes increasingly difficult to remain objective if you spend too long poring over your composition. To ensure a balanced, structured picture, stand up from time to time and look at your work from a distance or take a short break altogether. You'll be amazed how this changes your perspective.

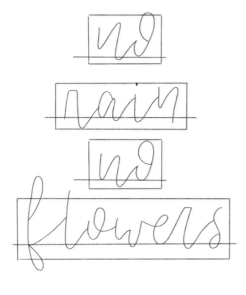

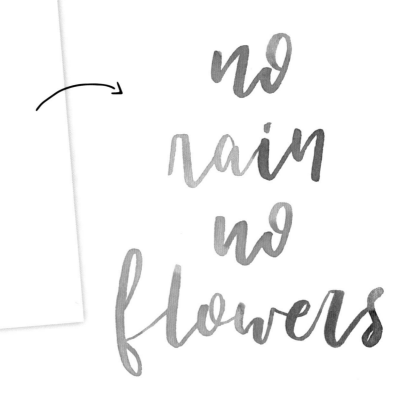

When you are happy with your illustration, it's time to get on with the lettering.

8. Sketch four pencil lines under one another in the middle of your paper. Leave plenty of space between the lines to give yourself enough room to write the words.

9. Draw rectangles over the lines to mark the areas for the words. Sketch the words inside them.

10. Take up your water brush pen and some watercolour paint. We chose a blue but you can, of course, use any other colour. Moisten the brush, and apply a little paint to a mixing palette. Gently squeeze a few drops of water into the blue with your pen and mix it with the brush nib to make the blue a little more watery.

Practise the lettering a few times first on a scrap piece of watercolour paper. Remember to increase the pressure on the brush on your downward lines. For the upward lines, just let the brush move lightly over the surface of the paper. The exercises on pages 104 to 105 will help you to perfect this hand movement.

11. Dip your brush in the thinned watercolour paint, and carefully paint over the sketched words. Don't worry if the paint runs out halfway through your word – simply pick up more paint and continue from your last wet stroke. The gradients will add interest to your lettering.

12. Wait until the wording is completely dry before you rub out the pencil lines. And now you have your fabulous art print to remind you of how much pleasure flowers bring us, no matter what the weather brings.

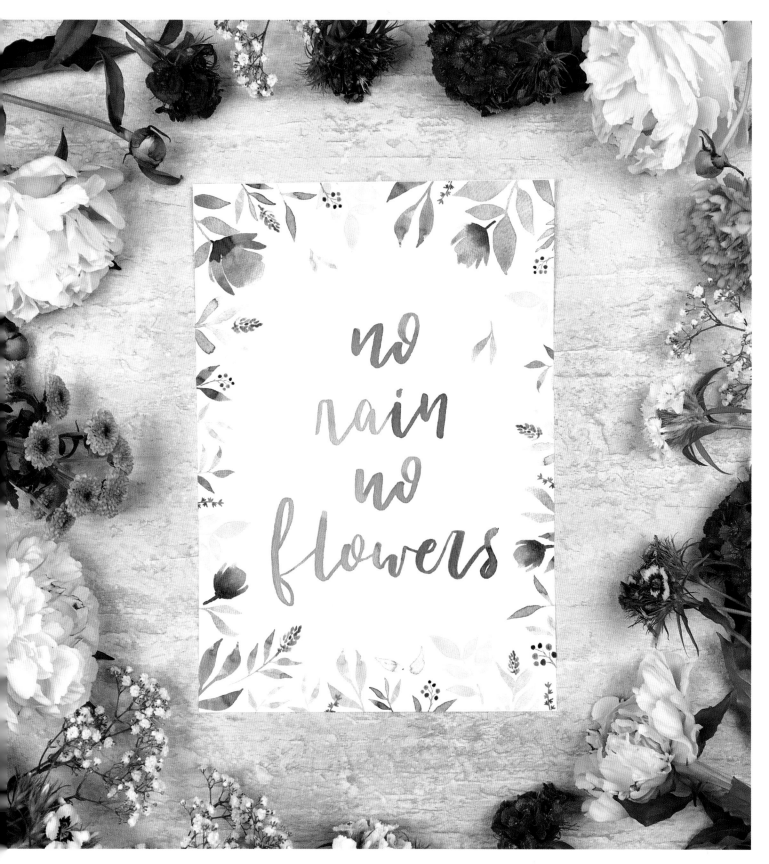

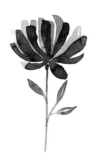

Chapter 3

CREATIVE TREASURE TROVE

Your own style develops, above all, from inspiration and experimentation. If you learn how to vary motifs and use decorative illustrations, you'll extend your skills and creativity even further.

The following pages are a creative treasure trove, with a wide range of designs and letter styles for you to choose from. You can try the projects on the previous pages using these different scripts or illustrations. You'll be amazed at how many unique works of art you can create in this way.

In the final section, you will find some exercise sheets for practising your lettering. Copy as many of these as you want to help perfect your lettering skills – practice makes perfect!

Happy drawing!

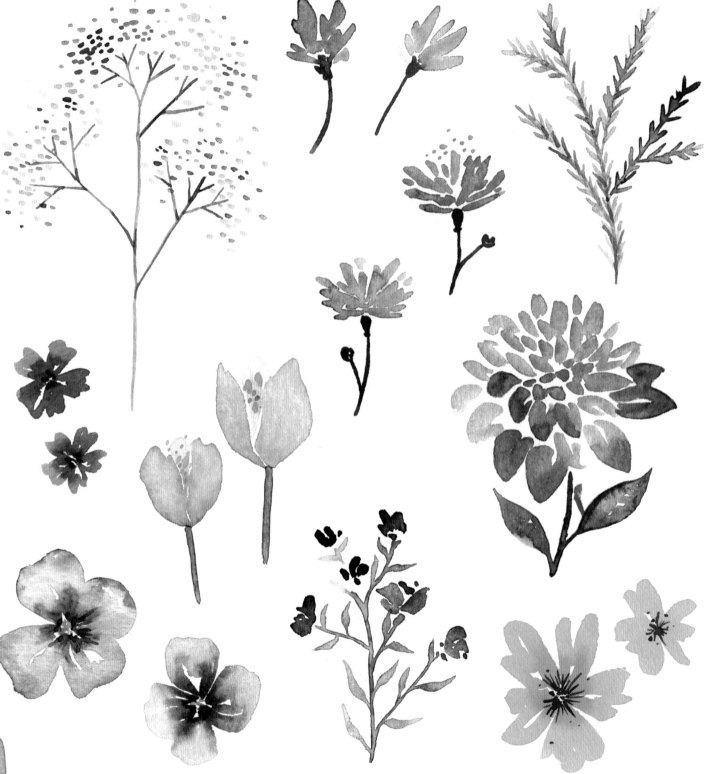

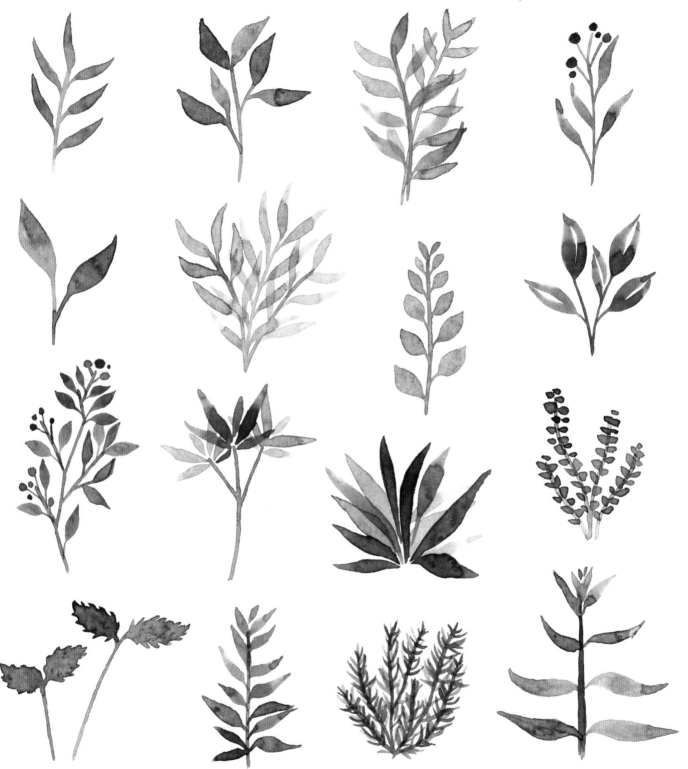

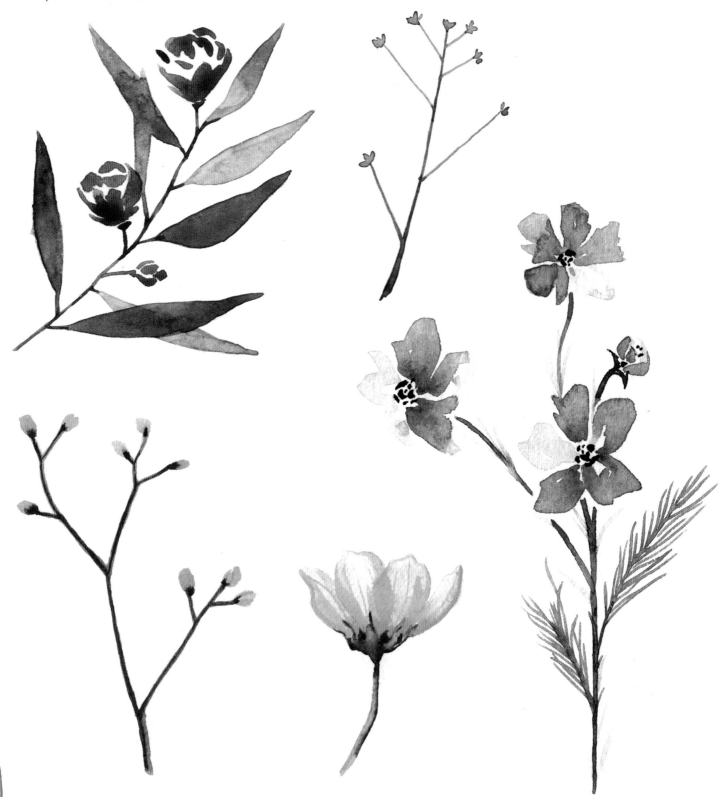

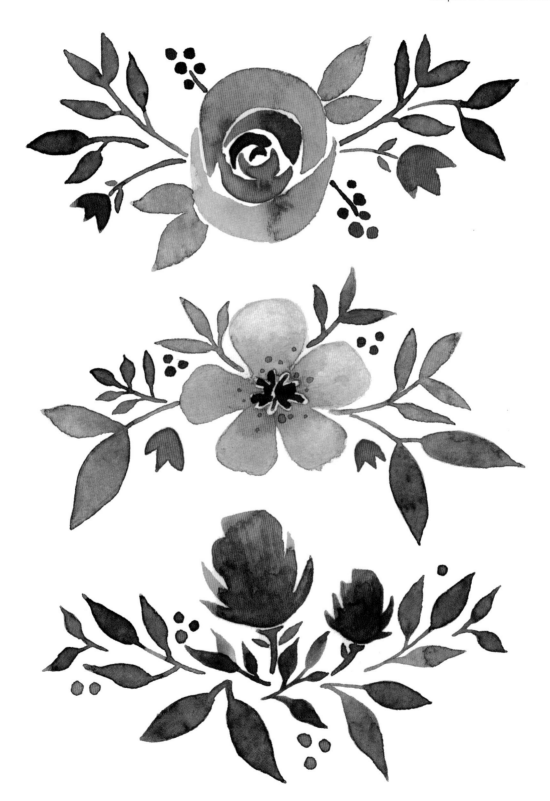

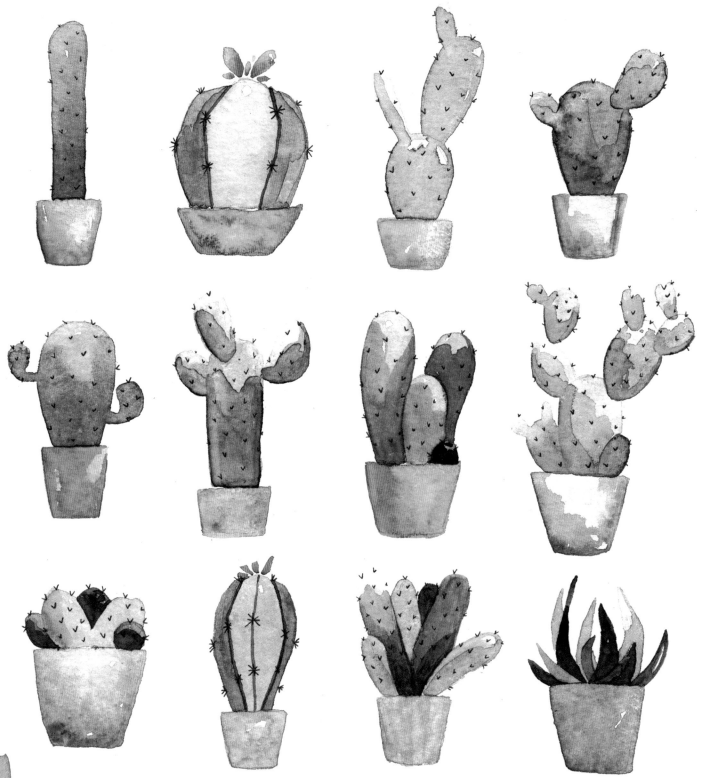

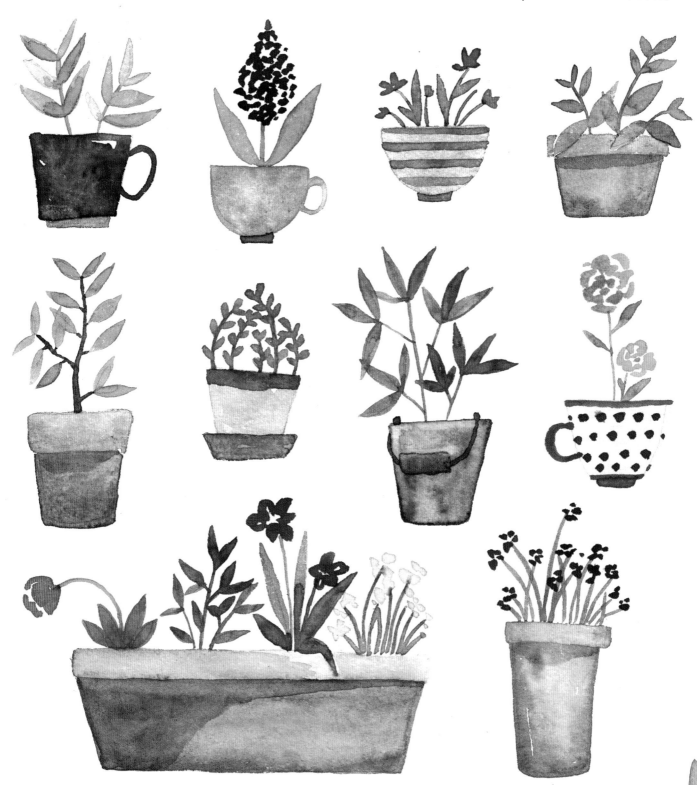

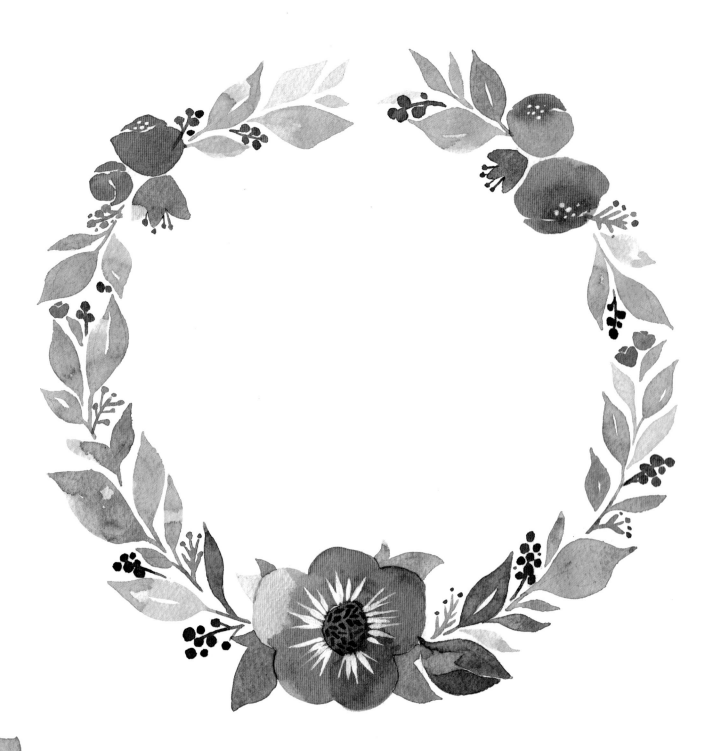

A B C D E
F G H I J K
L M N O P
Q R S T U
V W X Y Z

a b c d e

f g h i j k

l m n o p

q r s t u

v w x y z

A B C D E
F G H J J K
L M N O P
Q R S T U
V W X Y Z

a b c d e

f g h i j k

l m n o p

q r s t u

v w x y z

A B C D E
F G H I J K
L M N O P
Q R S T U
V W X Y Z

a b c d e

f g h i j k

l m n o p

q r s t u v

v w x y z

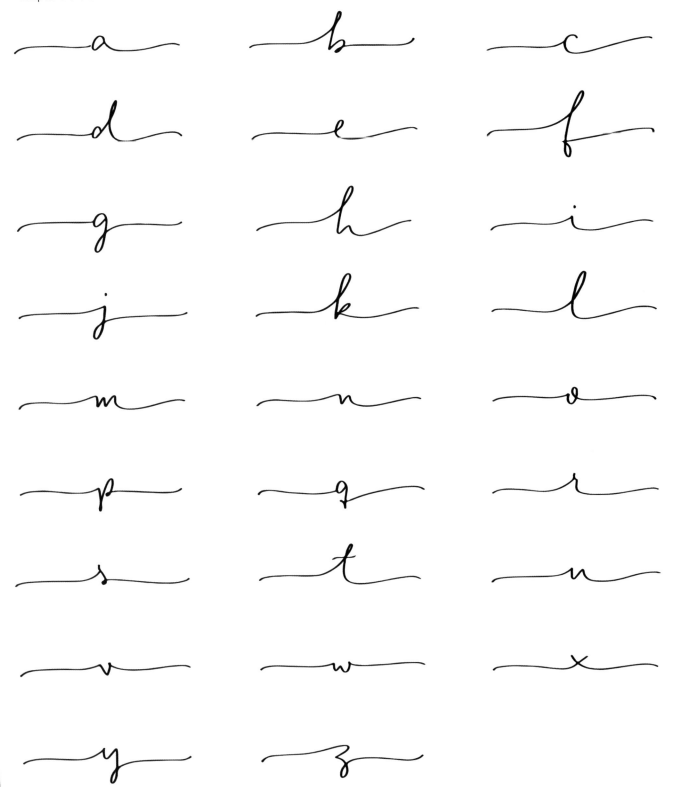

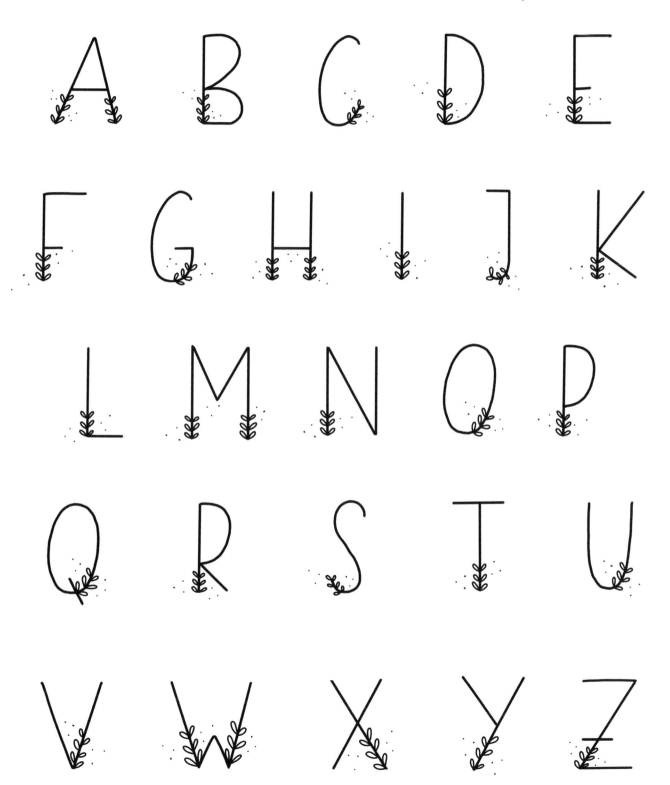

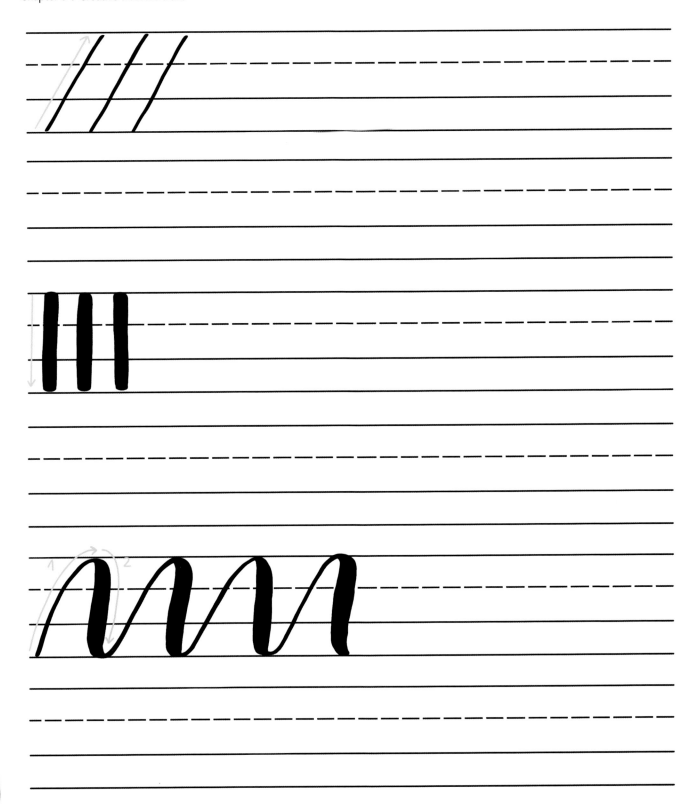

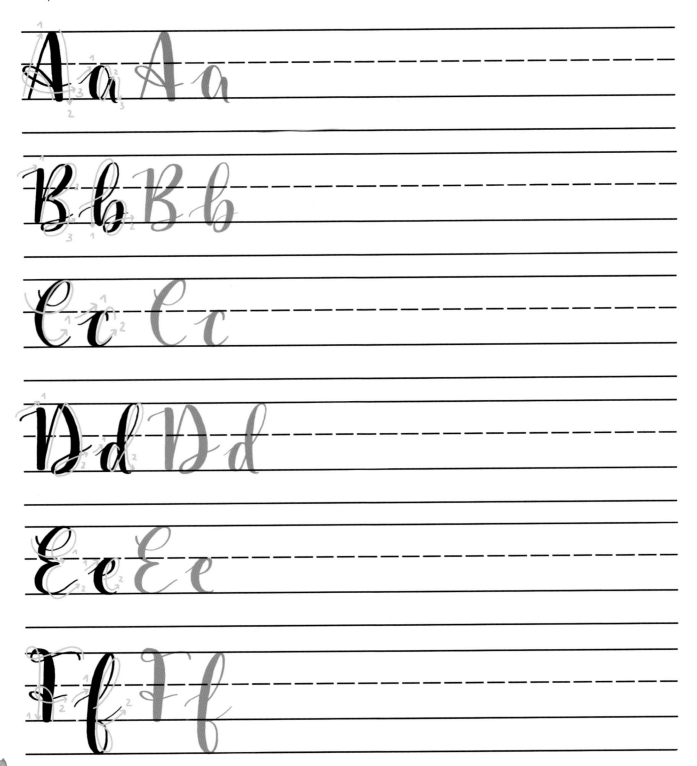

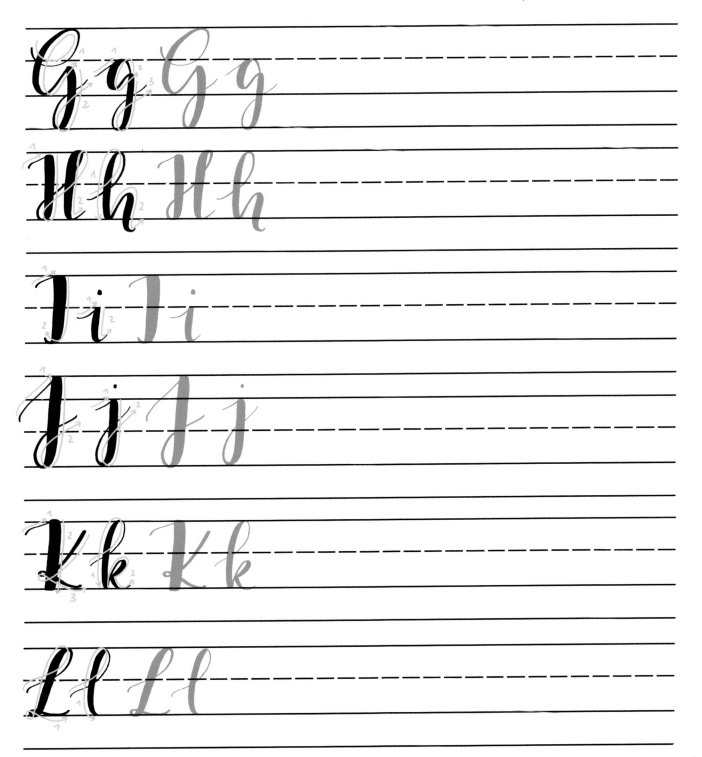

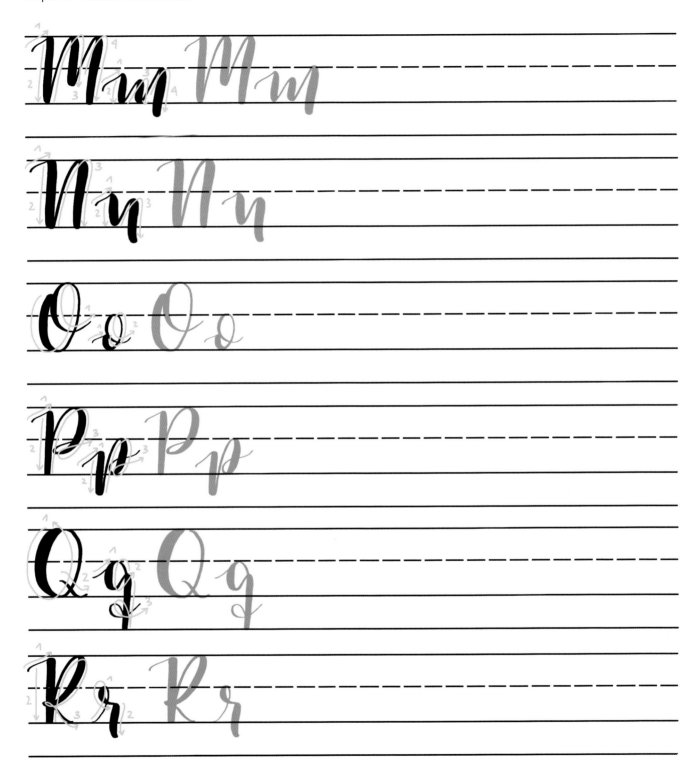

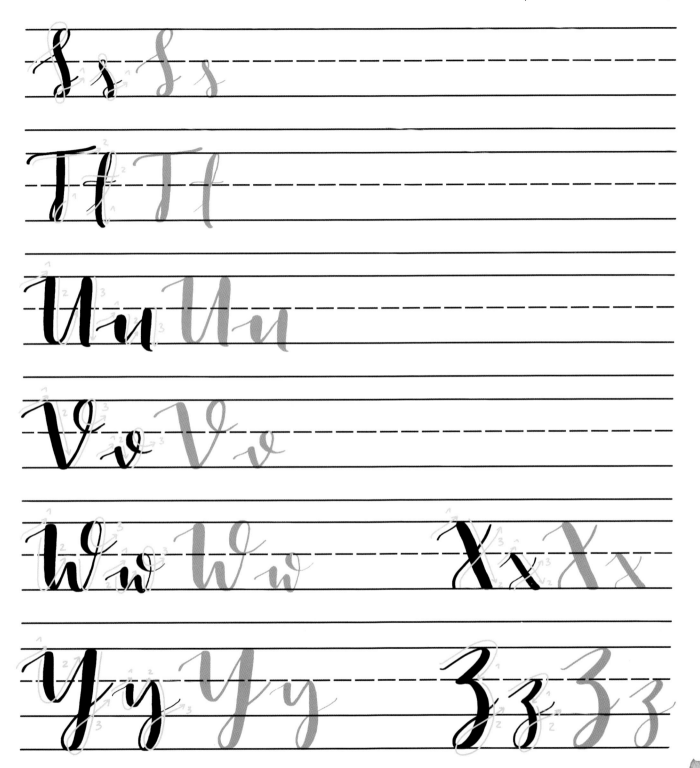

MATERIALS

Our thanks to the following companies for their kind support: Da Vinci, Edding, Faber-Castell, Hahnemühle, Royal Talens and Schmincke.

Royal Talens products:
Ecoline liquid watercolour paint (30ml) in the
 following colours: 202, 311, 318, 361, 506,
 600, 602, 654, 700
Ecoline Brush Pen

Schmincke Horadam Aquarell paint box:
In the following colours – 215, 224, 213, 214, 349,
 366, 353, 352, 474, 485, 494, 492, 481, 475, 519,
 524, 533, 534, 229, 655, 661, 649, 663, 780

Da Vinci Cosmotop-Spin in sizes 6, 8, 10, 12, 20

Hahnemühle watercolour papers:
Aquarellblock D'Aqua, 220gsm (100lbs) – rough
Cézanne Echt-Bütten Aquarell, 300gsm (140lbs) –
 hot-pressed and matt
Cornwall Aquarell, 450gsm (210lbs) – matt
Watercolour postcards, 230gsm (105lbs), pack of
 30 sheets measuring 10.5 x 14.8cm (4⅛ x 5¹³⁄₁₆in)
 – rough

Faber-Castell products:
Pencils, HB and 3B
Eraser
India ink Brush Pitt Artist pen, soft brush

Edding products:
1300 colourpen
88 office fineliner
1340 brushpen

THE AUTHORS

Sue Hiepler was born in Bonn in 1990.
After graduating in communication design,
she completed her studies with a qualification in
illustration. Once she had learnt various techniques,
she specialized in watercolour painting. Sue's
passion for watercolour led to her meeting her friend
and business partner Yasmin Reddig early in 2016.
Yasmin was born in Friedrichshafen in 1989, and has
likewise lived in lovely Bonn since 2014. Before that,
Yasmin had spent most of her life in South America
until 2012 when, in Buenos Aires, Argentina, she
discovered and fell in love with typography and
calligraphy during her university studies. Hand
lettering became her greatest passion, and it was
this revelation that led Yasmin to return to her native
Germany where she met Sue.

Early in 2017, the two friends opened a creative
studio in Bonn's old town, called May & Berry. Since
then, they have held regular workshops in hand
lettering and watercolour painting.

PUBLICATION DETAILS

First published in Great Britain in 2018

Search Press Limited
Wellwood, North Farm Road,
Tunbridge Wells, Kent TN2 3DR

Original German edition was published as *Handlettering Watercolor: Schön schreiben und mit Aquarellfarben illustrieren*
Copyright © 2017 frechverlag GmbH, 70499 Stuttgart, Germany (www.topp-kreativ.de)
This edition was published by arrangement with Claudia Böhme Rights & Literary Agency, Hannover, Germany (http://agency-boehme.com/en/)

Text copyright © Sue Hiepler & Yasmin Reddig 2018
Illustrations & lettering: Sue Hiepler & Yasmin Reddig
Product management: Lisa-Marie Weigel
Original German proofreader: Gabriele Betz, Tübingen
Original German layout: Sue Hiepler & Yasmin Reddig
Original typesetter: Tatjana Ströber

Design copyright © Search Press Ltd. 2018

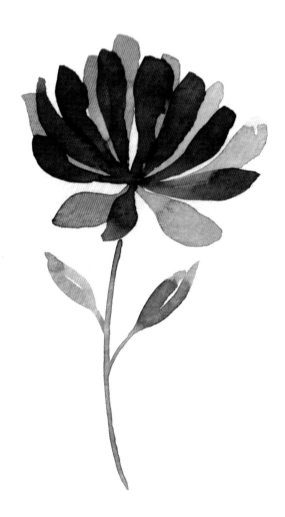

ISBN: 978-1-78221-664-3

Suppliers
For details of additional or alternative suppliers, please visit www.searchpress.com

Printed in China by 1010 Printing International Ltd.

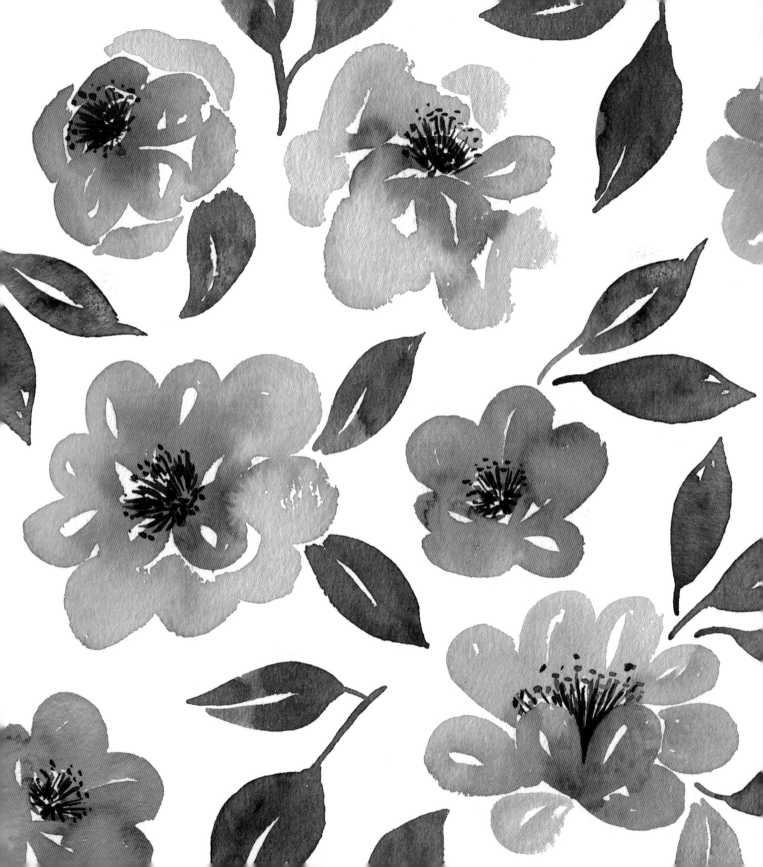